PORTRAITS IN OIL THE VAN WYK WAY

Helen Van Wyk

Art Instruction Associates, Sarasota, Florida
Distributed by North Light Books, Cincinnati, Ohio

PORTRAITS IN OIL THE VAN WYK WAY
by Helen Van Wyk

Paperback edition copyright ©2001
by Art Instruction Associates
5361 Kelly Drive, Sarasota, FL 34233

First published in hardcover, copyright ©1998
by Art Instruction Associates

Revised from original version of PORTRAITS IN OIL THE
VAN WYK WAY, Published by Art Instruction Associates, 1990

ISBN 0-929552-20-2

08 07 06 05 04 03 8 7 6 5 4 3

Distributed by North Light Books,
an imprint of F&W Publications
4700 East Galbraith Road, Cincinnati, OH 45236 USA
Phone: 513-531-2690 or 800-289-0963

Edited by Herb Rogoff

Art Direction by Stephen Bridges

Design by Laura Herrmann

Photography by Clark Linehan & Bobbie Bush

Indexing by Ann Fleury

Project coordinated by Hand Books Press
2 Briarstone Road, Rockport, MA 01966 USA
Phone: 978-546-3149, handbooks@adelphia.net

PRINTED IN CHINA

Metric Conversion Chart		
To Convert	To	Multiply By
Inches	Centimeters	2.54
Centimeters	Inches	.4
Feet	Centimeters	30.5
Centimeters	Feet	0.03
Yards	Meters	0.9
Meters	Yards	1.1
Sq. Inches	Sq. Centimeters	6.45
Sq. Centimeters	Sq. Inches	0.16
Sq. Feet	Sq. Meters	0.09
Sq. Meters	Sq. Feet	10.8
Sq. Yards	Sq. Meters	.08
Sq. Meters	Sq. Yards	1.2
Pounds	Kilograms	0.45
Kilograms	Pounds	2.2
Ounces	Grams	28.4
Grams	Ounces	0.04

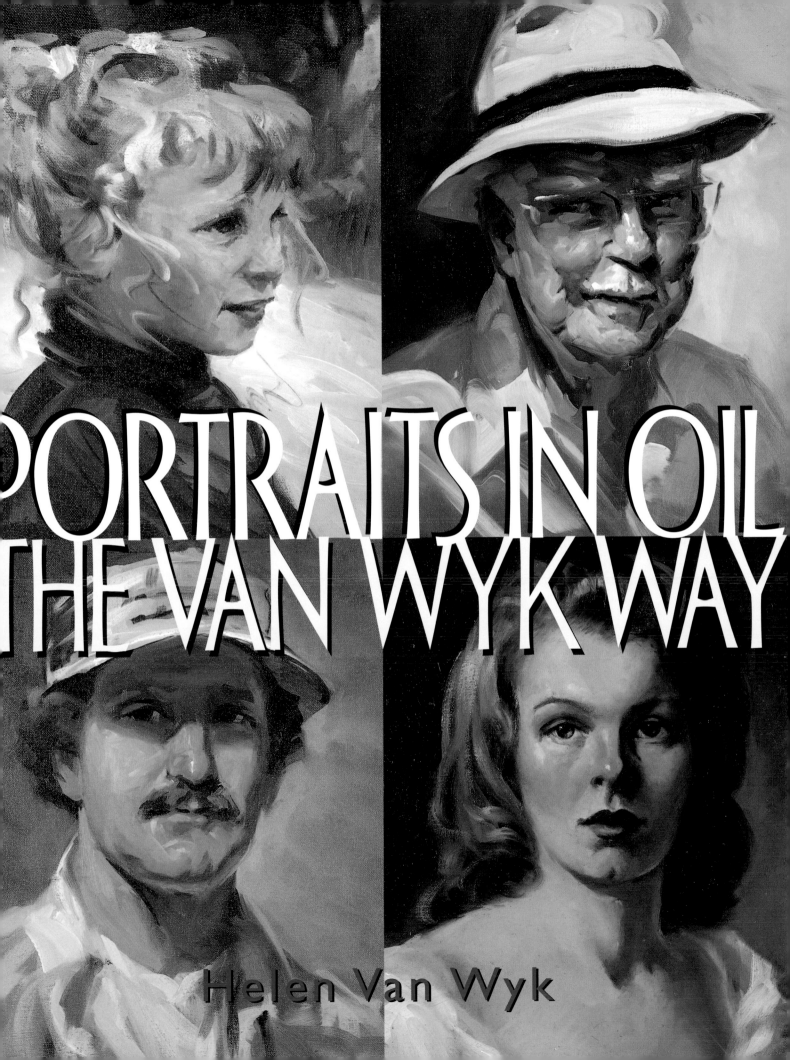

PORTRAITS IN OIL
THE VAN WYK WAY

Helen Van Wyk

Editor's Note

❧❦❧

When we began to compile material for the revision of this book, and others recently published, one fact stood out incontrovertibly: Helen was gone. Throughout her career, Helen was a prolific painter. Her creative output was prodigious. Sadly it had come to an end. All we had was a supply of color photographs and transparencies to illustrate the various books we wanted to publish. This library of photographs is what we now dip into for illustrations. A Van Wyk book consumes an extraordinary amount of artwork. It is very likely, then, that the same painting may show up in more than one book. We can't help that from happening; duplication, under these circumstances, is inevitable. We do want you to understand, however, that even though you may have seen the painting before, the lesson it teaches is entirely different from its previous use. This, after all, is the true purpose of a book of painting instruction.

When we published the original edition of *Portraits in Oil the Van Wyk Way,* we were forced, due to space limitations and economy, to omit some editorial matter and artwork. We are happy to say that they are included in this revised edition.

Many of you may be aware that the original edition of this book was printed primarily in black and white. Being anxious to present these valuable lessons in full color for this edition, we once again called upon the talents of Laura Elkins Stover, who by now has become familiar to you. We commissioned Laura to redo in color the progressive steps that Helen had initially painted in black and white. Laura, a student of Helen's for many years, has done a splendid job with a very difficult and, as you can well imagine, heart-wrenching assignment.

Finally, we wish to thank all the people whose likenesses appear on these pages. We have included the names of these models. You will also find some portraits of people whose identities have escaped our recognition. To those individuals, we humbly apologize.

Table of Contents

❧❧❧

Introduction

❧❧❧

This is a book about how to paint portraits well. It is not about the commercial aspect of portraiture. As a painter and especially as a teacher, I try not to advise anyone on business matters. I will say, however—and this is from my own experience—that the better the portrait you paint the better your business will be.

To introduce this instruction book to you, I'd like to relate two stories: one is about the man I studied with many years ago, M. A. Rasko; the other is about my mother, Alida DeBoer.

M. A. (which he preferred to his names Maximilian Aureal) Rasko was a task master, which made him a good teacher. He taught the basic principles of what he referred to as the "two-dimensional surface expression." All his lessons were so valuable that I have always abided by them.

After having been his student for some time, I told him, one day, that I wanted to paint a portrait. Mr. Rasko said nothing. He walked to a bowl of apples on his table, picked one up, placed it on the model stand, and left the studio. When he returned, it was just about the time that I had finished my assignment. Walking right past my easel, never once looking at it, he took the apple I had painted and returned it to the bowl with the others. "Now I'll look at your painting," Rasko said, "and from your painting I should be able to tell which apple was your model."

Many apples later, after I had learned from painting them about color, texture, structure and procedure, I got a real, live model. When that memorable day finally came, Rasko said, "Painting this person will be the same as painting all those apples, with only one difference— this model has an opinion and feelings."

That statement describes the only added complexity that portrait painting imposes on a painter. Consequently, the portrait painter has to add to his knowledge of painting, how to deal with his sitter's comfort and personality. He must then have to be able to paint him in such a way that the model, and those who know him, will like the portrait.

Every portrait painter deals with this pressure in his own way. My way is to concentrate on the factors that make a good looking painting of a human being, one that would be enjoyed by all, not just those who know the model. Don't we enjoy looking at Rembrandt's portraits? Yet, none of us knows whether his portraits were good likenesses of his models. Nor does anyone care.

My mother is an excellent model. She is all that an artist wants in a model: She poses well, has good features, is a striking-looking woman and, what's more, she gives the painter her complete attention and endorsement. She used to model frequently for my portrait classes until, one day, when she said to me, "Helen, I can't pose any more. Your students make me look funny." I had to agree with her, especially that particular day. One student painted Mother's eyes so big in relation to her other features that she looked as if she were from outer space. Another student painted the flesh color so pale that Mother looked ghostly. And one student painted her so small on the canvas that my mother, a stately women, looked like a Kewpie doll. But, crazily, all of these paintings had one thing in common—they were all likenesses of my mother, even though they were funny-looking.

By just trying to get a likeness, my students ignored, or didn't even realize, how important it was to paint a plausible presentation of their model—a real-life human being. If they would had done this, making Mother look human, their likenesses would have been acceptable instead of looking the way they did, thus sending Mother into retirement.

Fortunately for me, and beneficially for you, my mother agreed to pose for me. I've included the portrait's progression in this book along with a number of other portraits that present my graphic record of her over many years. Painting portraits, and being able to do a good one, offers a painter a unique satisfaction. I've directed the information in this book to those who strive for this type of painting achievement.

Helen Van Wyk
Rockport, Massachusetts

Posing the Model, Size and Placement

The model's position is your point of reference for the many hours of painting that you'll invest. Don't waste valuable painting time on a pose that isn't suitable — one that just doesn't look right or one that the model feels uncomfortable in. A pose that presents an advantageous point of view is a matter of opinion and taste not a matter of craft. Just plain common sense can help you choose a good pose, such as the following obvious examples:

❧ Pose children on a low model stand so you can look down at them, just the way we're accustomed to looking at children.

❧ Paint the strong, forceful executive type in a very direct, full-face pose.

❧ Pose a shy person with his eyes not focused directly at you.

Here are some basic rules to guide you in posing your model:

1. Look at him full face and study his features.

2. Experiment with positions from full face to profile.

3. Experiment with the all-important lighting. Try strong lighting for dramatic contrast. Try soft lighting for more subtle shadows. The choice is yours in relation to the model's appearance and personality.

4. Decide if the model's clothing is appropriate.

The elementary principles to follow to establish a good pose on your canvas are, as follows:

1. Make the head appear as close to life-size as possible, anywhere from seven inches to eleven inches. On a canvas that's larger than 12" x 16", actually measure the model's head with a ruler and record that size on the canvas. Making the head appear life-size is very practical because, by doing this, you immediately begin a semblance of a natural likeness. Making the head larger than life is hard to accept as real; making the head smaller than life can only look acceptable when it's proportioned to a smaller canvas.

2. When placing the head on the canvas, the chin should not be lower than the middle of the canvas from top to bottom. This is especially true when painting on a canvas that's approximately 20" x 24". When working on a smaller canvas, of course, the chin will be lower than one-half of the canvas since a smaller canvas does not necessarily mean reducing the size of the head from life-size. Obviously, the head will be higher on the canvas when you include more in the pose than just head and shoulders.

3. The ideal position of the head side to side is to place the pit of the eye, that's closer to your point of view, in the middle of the canvas, no matter what size the canvas is.

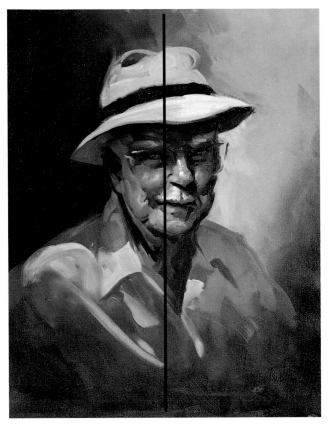

John Wentworth

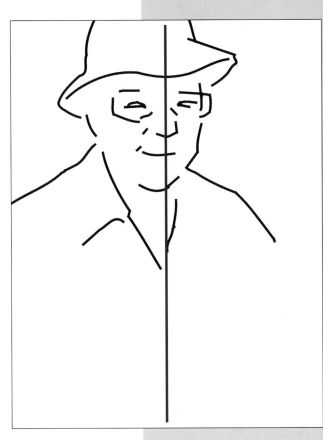

This position only applies, I might add, to the standard pose that is slightly less than full face.

4. The head should not face in the same direction as the body is facing. The pose of the model can range from dramatic to ordinary. The choice is dictated by the model's personality.

5. The normal perspective to view the model should be at eye level. Any deviation from this rule should result from the model's height, the model's age, and/or where the portrait will be hung. As I told you earlier, children will look younger if you look down on them. Tall people will look tall if you look up at them. John Wayne is a good example. If I were painting him, I'd look up at him, place his head high on the canvas and, maybe, make his head slightly larger than life. A model's personality also should contribute to your decision of your painting's point of view: look up at proud people; look down at demure people. In the final analysis, however, looking at the model at eye level is always safe.

6. How often have you heard someone say, "What a beautiful portrait! The eyes follow you wherever you go." A portrait will be more successful if the eyes of the model look at the viewer. You do this by having the model look directly at you as you paint his eyes. As a result, the eyes in the portrait will look at everyone who looks

Compare the placement of John Wentworth's head in his portrait with the diagram that depicts a possible incorrect placement of his head. In the diagram, the head is shown to be too high on the canvas and just a bit too much to the left. The vertical line in the diagram indicates that the pit of the eye closest to you (John's right eye) is not in the middle of the canvas from side to side. You can see in his portrait, however, how that eye pit is in the middle (indicated by the black line).

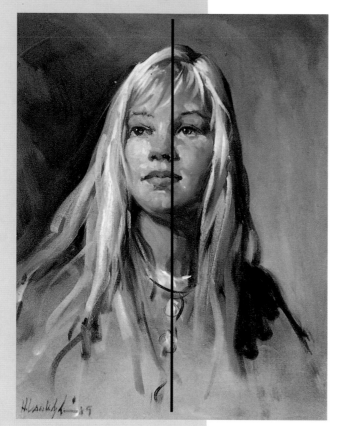

Melissa McDonald

The diagram shows the placement of Melissa McDonald's head to be too low, even though it's placed correctly from side to side. Compare this with the placement in the portrait. It's obvious that a high placement of the head contributes greatly to the pleasant appearance of the model. Notice that the eye closest to you (Melissa's left eye) is in the middle of the canvas from side to side (indicated by the black line).

at the painting regardless of where the viewer stands to see the portrait. Any other pose of the eyes will make the model not look at anyone, used only when you have a sitter who finds it difficult to look at you while he's posing; or if your model happens to have an air of aloofness. Be careful when you pose your sitter with eyes that are focused just above, and slightly to the side of, your eyes; you can easily end up with a portrait of a snob. Attitudes that are suggested by the mere focus of the eyes, therefore, should make you extra cautious about "eye contact."

7. **Never place the head in such a way that it looks as though it's directly in the middle of the canvas from side to side and from top to bottom.** The most natural position of a figure should be centrally located without appearing to be geometrically in the middle.

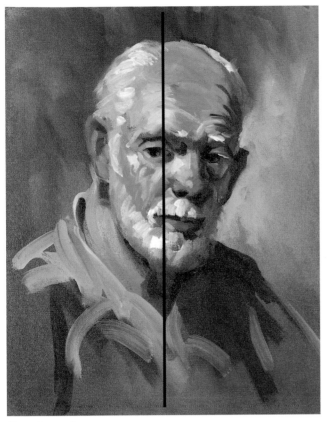

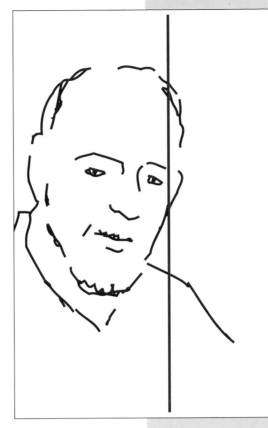

Don Stangel

Instruction for Placing the Head on the Canvas

Now that you've decided on the pose and the size of the canvas you'll work on, all your thoughts have to be directed to how you're going to make this person come to life on a flat surface. At this point, your canvas, not your model, becomes your priority. Start by limiting your thinking to positioning the pose from top to bottom and from side to side on your canvas. Do this with a few simple indications, or marks, with black paint thinned with turpentine. Don't do anything more on the canvas until you step back and look over this positioning. You have to be the judge:

Does it look too low? Does it look too high? Too much to the left? Too much to the right? Does it look too big? Does it look too small? Or does it look just right?

Keep these indications very simple so they can be easily washed away with a rag that's been dipped into turpentine; and simple enough that you won't feel that you've destroyed something precious.

You must remember that the placement and size of the head on the canvas is the nucleus of the portrait's appearance. After all, your model is going to be frozen on canvas in that position and size for a long time.

Placing the head incorrectly from side to side can be a detrimental factor in portraiture. The placement in the diagram makes it look as though the model, Don Stangel, is passing by or walking out of the canvas. Always have more space on the side of the canvas where the body is facing; or where the eyes are looking. The model should appear to be just approaching the space on the canvas. Putting the pit of the eye that's closest to you in the middle of the canvas from side to side is a good guarantee to get this proper placement. Only deviate from this rule when it is necessary because of the pose.

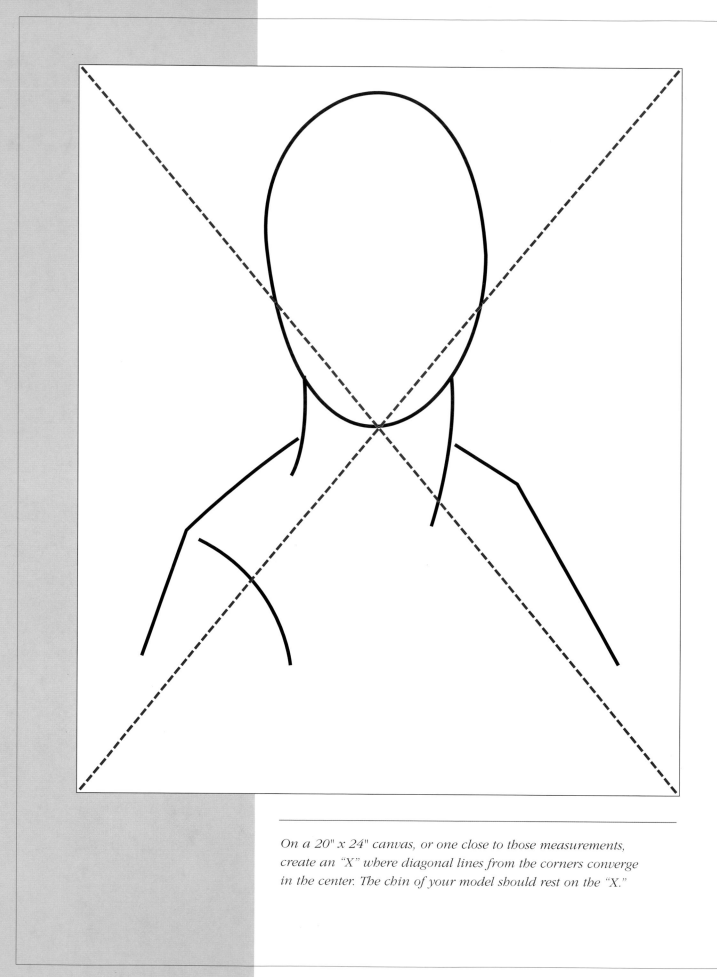

On a 20" x 24" canvas, or one close to those measurements, create an "X" where diagonal lines from the corners converge in the center. The chin of your model should rest on the "X."

Drawing

❦❧❦❧

Whenever I hear the word drawing I think of pencil, pen and ink, etchings and lithographs. I do this because the word drawing is used to describe how something is delineated through the use of a rigid implement. In painting, however, forms are never seen as a result of lines; they are seen because of contrasting tones. When one tone meets another, the result is a so-called line. Actually, this should be called an *edge* rather than a line, and because of this distinction, I like to say. "You draw a drawing; you paint a painting." So, drawing, when applied to painting, is in reality "shaping" or "forming." To be able to shape and form correctly with a brush, there are two extremely important factors the painter must learn. They are — *proportion* and *structure*.

Proportion

Proportion is the size relationship of one form to another. Correct proportioning is essential to recording an accurate image. Indications of the proper proportions of the features guide the application of contrasting tones that will record the features correctly.

Before you can determine the sizes of the features, you must have the overall size of the head and shoulders proportioned to the size of the canvas. This is always established in

the placement stage *(Chapter 1)*. Getting the proportion of the features then becomes a matter of dividing this overall form into fractions, or into parts that can be compared to each other. To begin a thorough understanding of the proportions of the face, look at yourself full face in the mirror. Actually hold a ruler against your nose with one end of it at your chin. See how many inches your entire head measures, and mark that measurement on a piece of paper. Now, notice how the following basic proportions apply to your own face:

1. **The eyes are one-half the distance between the top of the head and the chin.** The head can be loosely divided into four somewhat equal parts: (1) The head as it recedes from the forehead; (2) The forehead; (3) The nose area; (4) The mouth area from the nose to the chin.

2. **The proportion of the eyes to the mouth equals the distance from the end of the nose to the chin.** This proportion is often the same as the eyes to the hairline.

3. **The size of the ears is much the size of the nose.** The position of the ears in relation to the nose greatly varies according to the tip or tilt of the head. A good way to check whether the model's pose has changed is to compare the relationship of the nose to the ears.

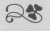

The horizontal lines show how the face can be divided into four equal parts. An easy way to get the proportions of the face correct, in relation to each other, is to compare all the shapes of the face to the size of the nose. Centrally located on the face, the nose is a good gauge to use for this proportional purpose.

Remember, proportion is the size relationship of one shape to another. For example, if you make the nose long and you make all the other shapes in relation to that length, the nose, then, can't be said to be too long. Here is a good rule to follow when drawing: **Always look where you have been and compare to it what you are yet to do.** Also, by constantly lining up one feature to another, such as the eyes in relation to the corners of the mouth, you will have a better chance to keep the features in the same perspective.

This self portrait was painted at about the time that I was to leave Rasko to go out on my own. He assigned me to do this self portrait as the final lesson in the eighteen months I had studied with him privately. He put some of his touches on the portrait but not enough that I couldn't consider it to be my own creation.

4. No matter what position the head is viewed in, the corners of the mouth are in line with the iris of the eyes; the nostrils are in line with the pits of the eyes.

5. The middle of the breast is usually one head size down from the chin.

As reliable as these basic proportions are, I would like to suggest that you "size up" each model on your own so you can check and correct proportions in relation to your subject. The system that I use to measure my models is one that artists have been using for years. It is actually easier to do than to explain, so read carefully. Hold your brush with handle up at arm's length (this is the only distance that you can't vary), then focus on the feature in question — let's say — the length of the nose from the eyebrows to the nostrils. Move the brush handle in line with your focus on that feature. Now, move your hand up the brush handle

until, with your thumb, you can section off the end of the brush to the size the feature appears to be on the brush at arm's length. Compare this indication with another feature — let's say — the mouth area from the nose to the chin. This comparison will tell you that these sizes are the same, are larger or smaller. To further explain: look in a mirror and ask yourself what proportion the width of your head is in relation to its length. Is it one-half? Two thirds? Equal? Now, actually hold up a brush across your face and mark off its size. Then compare that size to your face's length. You can now see how marking the proportion on the brush will help your judgment. When working from the model you can't very well walk up to him and make these comparisons with your brush against his face. Instead, you can measure and compare them by recording how they look on your brush handle at arm's length.

Structure and Planes

The structure of the face is caused by its anatomy. When this structure has to be recorded with paint, it has to be thought of in terms of planes.

- **The Forehead.** From side to side the forehead should be thought of as three planes: two temples and the front plane. From the top down, the forehead's structure is in two planes: the upper, rigid part that spans the skull; the lower part that is called the brow.

- **The Eyes.** Think of the eye area as two planes from side to side: the eyeball inserted in the socket makes a projecting plane and a receding plane. The entire eye area, or socket, is only one plane from top to bottom, called an underplane. Embedded in this underplane is a complex structure consisting of six parts, from the brow to the bottom of the socket.

- **The Nose.** The nose has four basic planes: two sides, the front and the underplane, where the nostrils are. Its structural characteristic, from the top down, is in two planes:

the upper part where the skin spans the bone and the end where just cartilage supports its form. Planes all have to be carefully scrutinized and painted accordingly.

- **The Cheeks.** The cheeks have front and side planes and, from the top down, have two structural planes: where the bone is and the part that comes down to meet the jaw and mouth construction.

- **The Mouth.** The mouth is the most complicated feature and the most difficult to deal with because it moves so much. Each lip has three planes from side to side, and each has two planes from top to bottom. Dealing with, and painting, the correct shape of each one of the planes is full of jeopardy. And to make matters even more troublesome for the portrait painter, the middle plane of the upper lip contains the philtrum, the hollow that runs down from the nostrils to the upper lip. The corners of the mouth also have three structural parts. The complexity of these muscles greatly influences the expression of the entire lower portion of the face. The upper lip has three muscles, the lower lip has two.

- **The Jaw.** The jaw has two structural parts that make up the receding planes on either side of the face, ending at the ears, and have a top and underplane.

- **The Chin.** The chin is a feature that is between the two jaws. It has three planes from side to side, and three planes from top to bottom. The cleft in the chin is part of the front plane. If you think of the cleft as a division instead of as part of the front plane, you'll end up painting it as an incision.

- **The Neck.** I think of the neck in four planes: the vocal area, the two sides and the back area that starts at the ears.

- **The Ears.** Never forget them but don't make an issue of them either. There's nothing worse than a portrait of an ear with a man hanging nearby.

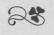

The basic planes of the face are illustrated by the lines that are drawn into my face. The front plane of the face is unlined. The side planes are described with diagonal lines. The underplanes are indicated by vertical lines. Compare the planes on the cast to the ones on my self portrait to see that basic planes even apply to young women.

My description and analysis of the features of the face will help you form them successfully. You've noticed, I'm sure, that I listed them from the top of the face — at the forehead — and ended at the neck. This progression is a clue to a procedure that can put you in control of recording an accurate and sensible painting of a model's face. The careful observation that results from this analysis can make you direct your scrutiny and then your brush strokes to put a face together so that it looks as though it can function to talk and respond with expression. This is a major factor to getting a likeness. Each and every person has individual peculiarities embedded in each of these structural parts.

The oval shapes on my face point out the many parts of the overall structure of my face. Careful consideration should be directed to these parts of the face. The small diagram of the eye (inset on left) shows its eight planes, indicated by the numbers. Each plane has to be observed, considered and painted. This is best done by starting at the eyebrow and painting each plane from that point down. The diagram of the five muscles of the lips (inset on right) shows where the muscles touch each other. The darkest dark tones of the mouth area are where the muscles don't touch.

1
2
3
4
5
6
7
8

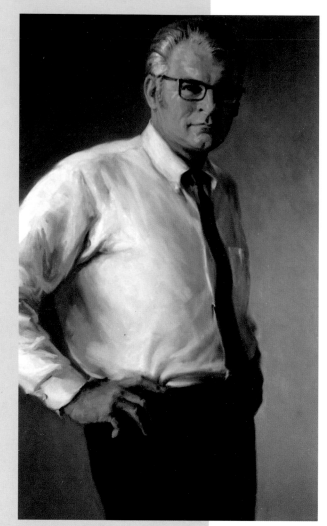

Sam DeBoer

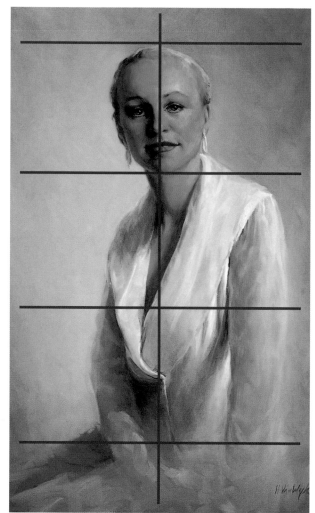

Sheila Nemes

Many of the portraits in this book weren't commissioned. A majority of them are sketches painted in front of art groups in various parts of the country. The portrait shown here, though casually posed, can be considered to be a formal portrait. It's of my brother, Sam DeBoer, whom I always fancied as John Wayne. Sam, incidentally, fell into this pose quite easily and naturally.

When planning this portrait of Sheila Nemes, a striking looking woman and excellent model, there was no question in my mind what the shape of the canvas would be: long and narrow. To arrive at the size of the canvas — 20" x 30" — I first had to decide how much of the pose I wanted to include, certainly down to the hands that do not show but we know are there. By measuring the head size in relation to the rest of the pose, I found that it was one-third of the entire distance from head to hands. By making the head eight inches high, I knew that I could easily paint down to an indication of hands. I decided to make the canvas thirty inches long which would give me enough room to situate the pose with some space to spare. Since a good composition is primarily getting the model and pose to fit nicely on the size of the canvas, preliminary mathematical calculation is more reliable that trying to get it with just talent.

<div style="text-align: center;">

Chapter 3

Lighting and the Five Tone Values

</div>

Despite the abundance of illumination in our electrified world, the painter should be concerned with only one source of light. As a painter, you must respect the effect of this one source of light, because it causes five tone values:

The Body Tone: *The illuminated part of the subject.*

The Body Shadow: *The part of the subject that's turned away from the light.*

The Cast Shadow: *An area shadowed by an object that stands in the way of the light.*

The Reflection: *A lighter tone in the shadow that's caused by the subject's surrounding area.*

The Highlight: *A spot that's in such a direct line with the light that the subject's color is obscured in the glaring illumination.*

Every painting — whether a mere apple or a lovely model — is made up of these five tone values. The very essence of the painting process is always the same. If you can see your models in terms of the tone values you will be able to paint them. Train your eye to look for and identify the five tones. Your colors will only look right if they are the correct tones. All the planes of the face become part of these tones. All the planes

are influenced by the kind of light that shines on them. For example:

- Light from above makes all the under planes shadowed.

- Light from the left makes all the right side planes shadowed.

- All protruding planes will cast shadows on planes next to them.

Shapes of the Shadows

It is appropriate that I am using the portrait I painted of Ralph Entwhistle *(page 20)* to illustrate a chapter about the importance of lighting and the shapes of light and dark contrasts. Ralph Entwhistle was my first art teacher. He made me understand that the possibility of recording with paint a feature's shape is completely dependent upon lighting and the contrasting tones that lighting causes.

In commissioned portraiture, you should pose your model in lighting that will show off his features to advantage. When you're not under the pressure of commission, you may often be motivated to paint someone just because you see intriguing lighting on a person's face. *Painters must always see people in patterns of light and dark.*

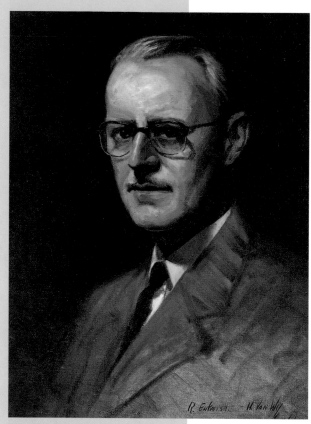

Ralph Entwhistle

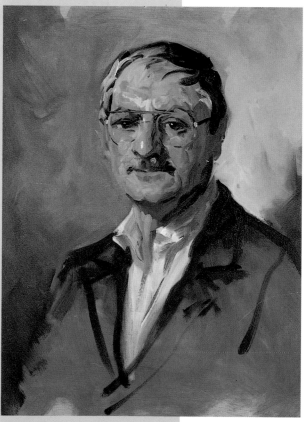

Herb Rogoff

Let's examine the contrasts on the portrait of Ralph Entwhistle that I painted many years ago, years after I first heard him say: "Look for the shapes of the shadows":

1. The entire eye sockets are in shadow.
2. There are cast shadows on his cheeks from his eyeglasses.
3. There's a cast shadow from his nose on his upper lip.
4. The upper lip of his mouth is in shadow.
5. There's a shadow that's cast on his collar from his head.

All of these shapes indicate that the light was from above.

Now, let's compare these shapes of shadows with those in the sketch that I painted of Herb Rogoff. Different lighting caused a pattern of light and dark that's very unlike the one in Entwhistle's portrait, even though the pose is much the same. All the shadows on Herb's face were caused by lighting from a lower window and more from the left than from the front. The portrait of Ralph Entwhistle was painted in his studio which had a skylight; the one of Herb was painted in my studio which has a lower source of light. Of course, you can control your light by using spotlights on your models. Just make sure that your model's face is being influenced by one source of light. This is the trick to making his features look three dimensional. Too many sources of light will make his face look flat, and you will not see enough contrasting tones to record him on a flat surface. Always be aware of how limited the flat surface is. The Old Masters surely recognized and respected the difference between the real and pictorial. Study the portraits of Van Dyck, Rembrandt and Sargent and see how sensible and consistent all the tone values are on the features. They all look as though they've been influenced by one source of light.

The lighting that I used for my portrait of Herb Rogoff (on left) came from a lower source and from the left. The lighting for my painting of Ralph Entwhistle came from above. The cast shadows on the faces and on their shoulders are clear evidence of the lighting direction.

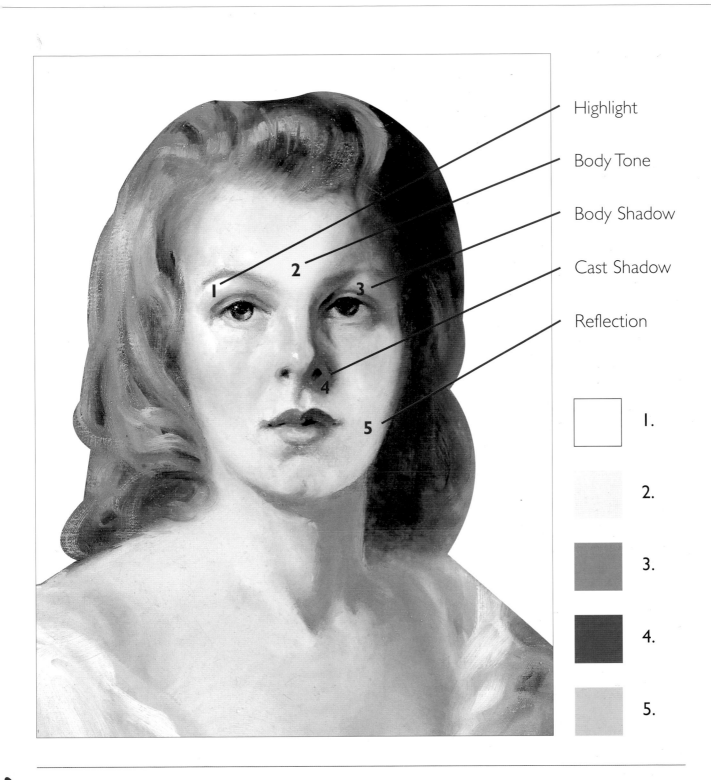

Highlight

Body Tone

Body Shadow

Cast Shadow

Reflection

1.

2.

3.

4.

5.

The boxes numbered 1, 2, 3, 4 and 5 are the values of the five basic tones that were used to record a three-dimensional effect on a flat surface. These numbers correspond to the ones that appear on the face in this tonal illustration. These tones, of course, also record a likeness of the model. You, as a painter, must recognize what your major problem is: dimension, often used as a synonym for realism. Our real world is three-dimensional so our canvas has to record this reality. See where these tones are on my face. Make sure that the body tone is painted in wherever the face planes are toward the light. The body shadow tone is used when the face planes cannot be illuminated. This consistency of a simple light and dark pattern lends solidity to the form instead of creating a disjointed look.

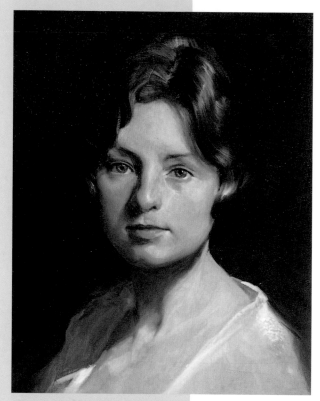

A dark background: Makes flesh colors look light and lively. *Model: Janet Kierstead.*

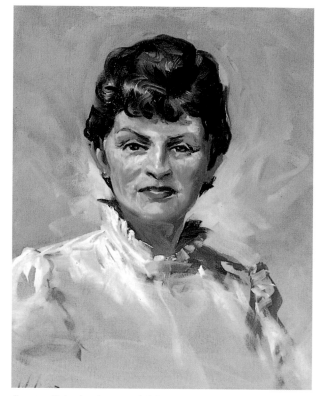

A very light background: Not to be used without first ruling out an easier tone. *Model: Helen Murphy.*

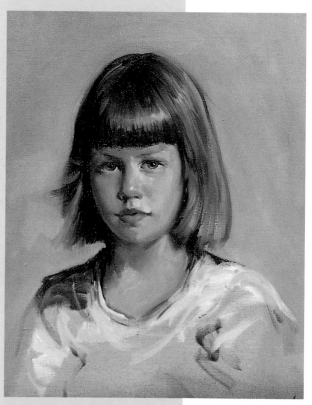

A medium tone: The easiest one to use.
Model: Kathy Hunt

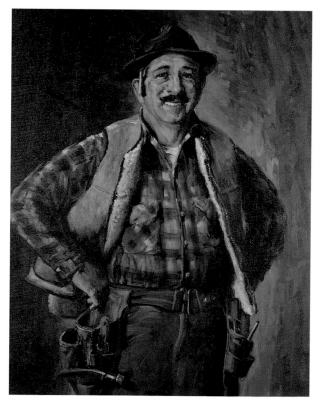

A gradation from light to dark: My favorite of them all.
Model: William Roche.

How to Paint a Portrait's Background

Portrait composition is divided into two areas — the subject and the background. The role the background must play is a supporting one. It's not that easy, however, to make something appear unnoticed yet suitable. A background has to be a tonal and color asset to the figure. Here are some basic choices for backgrounds and why you should use them:

An Overall Dark Background

1. To show off the beauty of light hair.
2. To accentuate the beauty of light skin, making sure that the background doesn't obscure the color and tone of the hair.
3. To make it possible to use light shadow tone on the face.
4. To prevent a strong color statement in the background.
5. To present a stark appearance.

An Overall Light Background

1. To show off dark hair.
2. To present a very feminine, airy quality.
3. To give the appearance that the model is outdoors.
4. To make the skin look dark.

A Medium Tone – the Most Common Background

1. Makes it possible for the skin tone on the light side to be a lighter tone than the background and, by contrast, the shadow can be darker than the background.
2. Since this background is the easiest of all to use, make use of it when pressured by time.

A Graduation from Light to Dark

1. For a forceful, dimensional look.
2. The most difficult one to paint because of the blending of contrasting tones and the variation and gradation of the background color into darker, shadowed versions of the background color.
3. The most effective type of background to choose and the one that offers the most variations.

Putting all of this into practice, let's now see how to choose the best color for a background:

1. Decide first on its tone: light, medium, dark or varied.
2. Realize that a successful background is always one of grayed colors. This is simply

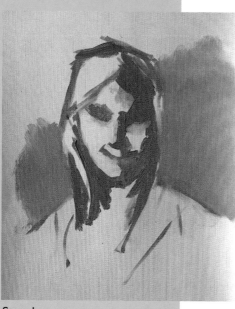

Step 1.

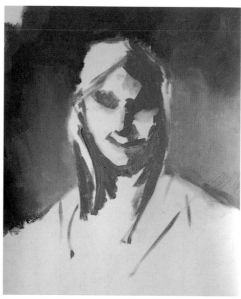

Step 2.

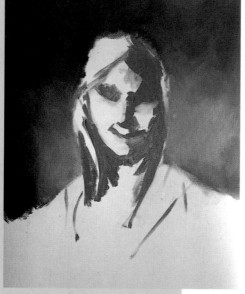

Step 3.

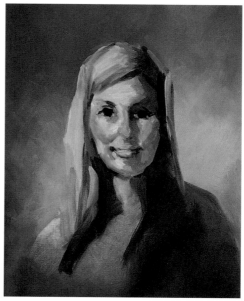

Step 4.

Here are four steps to show how to lay in a background of gradated tone from light to dark. (Color decisions and procedure are described on Page 25) **Step 4** *is ideal for a second sitting because, from this stage, the model's features could easily be zeroed in by adding more light to the body tone and darker accents to the shadows.*

done by mixing colors into black and white or toning a color's intensity down with the color's complement.

3. Decide whether a warm or cool color is best suited to the model.

4. Decide on dramatic colors or muted ones.

5. Decide what color and tone will blend in with the model's clothing.

6. Consider where the portrait will hang. You'll find that this is the least of your concerns. If

the background suits the model it will pretty much fit into any room.

Now that the types of backgrounds have been analyzed, here is the best way to paint a successful background:

Step 1. Always start painting around the head and overlapping the color into the shape of the hair so the hair can later be painted out and over that completed background area.

Step 2. Lay in the background color in

strokes that are no longer than one-and-a-half inches. This rhythm makes slight variations that suggest atmosphere. If a smooth background is desired, these shorter brush strokes can later be smoothed out better with a large blending brush.

Step 3. Continue painting the tones and colors, ending at the edges of the canvas.

Step 4. Paint the color of the background across the bottom of the canvas so the clothing can be painted down into it. This also creates atmosphere and fuses the body out of focus as it comes to the bottom of the canvas thus making the head look more important.

How One Source of Light Dictates Tonal Contrasts

Again we have to have an understanding of lighting to paint effective variations of tone in a background.

In my monochromatic painting of a ball *(Figure 1, inset, page 26),* we see lighting from the right shining on it. It makes the right side of the ball light and the left side dark (in shadow). The light continues in this direction, making the background light on the left side of the ball. Since the light couldn't strike the background directly on the right side of the ball, the tone of the background is not illuminated. This same organization of tone is seen in the background of my portrait of Mrs. Bokma *(Figure 2).* The right side of the face is illuminated by lighting from the right. The background is light where the lighting is directed. This gradation of tone looks natural and when this is done dramatically or delicately, it becomes a plausible presentation of the lighting in the room.

How to Paint a Tonal Graduation in Color

Start at the light area with the color you want. For this example, I'll use a warm gray, which happens to be my favorite background color:

Step 1. With white, black, Burnt Umber and a touch of Thalo Blue, making a warm gray of a light value, paint in the light area of the background that's behind the shadow side of the face. At the same time, cut the color slightly into the shape of the shadowed area, especially where the hair is and wherever the folds of the clothing are. Extend this color out farther than you want it to appear toward the outer edges of the canvas.

Step 2. Now, with a darker version of this mixture (by adding more Thalo Blue and more Burnt Umber into the same amounts of black and white), paint into the initial tone and extend it around the other side of the head and more toward the edges of the canvas. Extend this toned color out beyond where you want it to appear.

Step 3. Next, you'll want to turn this color into shadow. You do this not only by darkening with more black but also by adding its complementary color, in this case, Thalo Blue and a touch of Alizarin Crimson. Paint this in where you want the background color to fall into shadow.

Step 4. With more Burnt Umber and some Indian Red into the mixture, turning the background color once again to warm, fill in the remaining areas of the background on the right and left of the canvas. Use this color also to fill in the area at the bottom of the canvas. Subsequently, the clothing can be painted down into this area and will help to force the clothing color out of focus. The initial lay-in of the background should look finished. While it's true that you will have to adjust it to some degree as the portrait develops, you should never have to completely repaint your background. Look at the backgrounds in all the portraits in this book. You will see how this tonal principle is always employed.

In conclusion, this step-by-step procedure hardly describes the involvement that painting a background can be. The purpose of a background is to try to make paint look like an atmospheric condition that's suitable to the

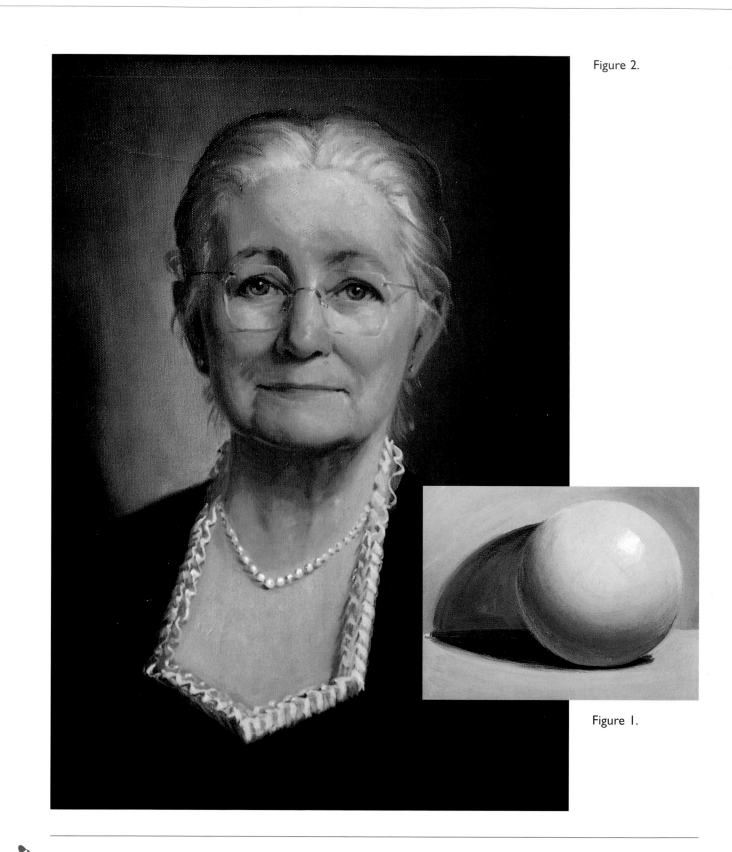

Figure 2.

Figure 1.

*In my painting of the ball you can see how the very nature of lighting is the clue to arranging the tone values in a background and on the figure to record dimension. Look at the tones in both the sphere (**Figure 1**) and the portrait of Mrs. Bokma (**Figure 2**). They are basically the same even though the objects are decidedly different. A lighting effect is always the same; the shapes it shines on are different.*

model. It takes a lot of playing with little strokes and a lot of blending of colors, but with practice and patience an illusion of atmosphere will appear.

Important: When painting backgrounds, don't ever put in a change of tone that will distract from the head. Tonal changes should always be against the outline of the head or toward the edges of the canvas.

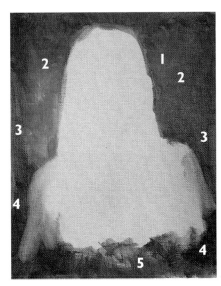

Figure 1.

Sister Teresa

Figure 2.

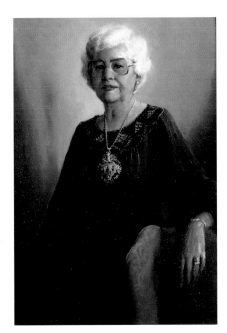

Edith Dean

Sister Teresa was a student of mine and she consented to pose for the portrait demonstration during my workshop. The numbers in **Figure 1** identify the colors that were initially laid in the background before they were blended. They are as follows:

1. The color, Burnt Sienna, light and grayed.
2. The color, Burnt Sienna, a bit darker and not grayed.
3. The color's complement, Thalo Blue with white.
4. The color, Burnt Sienna again, but darker.
5. The color's complement, darker Thalo Blue grayed.

Edith Dean commissioned me to paint this portrait of her and specifically wanted me to include the huge diamond-studded jade pendent she is shown wearing. The numbers in **Figure 2** identify the colors that were initially laid in the background before they were blended.

1. The color, Thalo Green, very light and grayed.
2. The color, Thalo Green, a bit darker and not grayed.
3. The color's complement, Alizarin Crimson grayed with green.
4. The color, Thalo Green, again, but much darker.
5. The color's complement, Alizarin Crimson darkened with green.

Chapter 5

The Beginning Stages Of a Portrait

After the planning stage — pose, size, placement and proportions — the actual painting process can begin. The initial stages of painting are difficult for beginners, most of whom fail to realize that they have to make an accurate investment that will be further developed. Many students do this stage in a sloppy way which impedes their progress, bogging them down in correction rather than refinement. Other students try to make this stage look like the last stage, and get involved in detail, not recognizing that it has to be a simplified, yet correct, beginning.

To put this stage in its proper place, think of all the things that could more easily be done at a future painting session:

❧ Save all jewelry and eyeglasses for the more final touches of your portrait. This is the most obvious.

❧ Less obvious is the hair that overlaps the background, the face and ears. Save this also for the later stages of your portrait.

❧ Save any blemishes in the skin that you have to paint because they are such identifying parts of the model. These would be moles, wrinkles and others. Even the shine on the forehead, cheeks, nose and chin could be more easily added to an already painted skin tone. In the shadow area, the very dark tones that are seen in the nostrils, the corners of the mouth and the redness of the lips can also be done later.

You will be more successful beginning your portrait if you reduce your observation of the model to patterns of light and dark. After all, this is the only thing that your paint can record — not the model's feelings, expressions, hair, skin or likeness. You and your paint have to be cold blooded at this time: translating the subject into two tones — light and shadow. This can be done in color or more simply in tones of gray. Here is a basic approach, in my portrait sketch of a lovely woman, Audrey Ockenga:

STAGE ONE Placement of the head on the canvas. The head is actual size on a 20" x 24" canvas. The chin will be about in the center of the canvas.

STAGE TWO I have drawn lines to describe the proportions of the face and where the shoulders line up with the head.

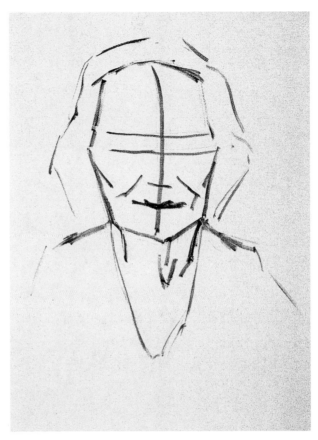

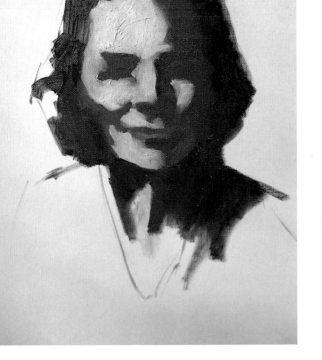

STAGE THREE With a dark tone of black, white, Alizarin Crimson and Sap Green — making a neutral gray — paint in the shape of the shadow that's seen on the receding plane and the under-planes of the forehead, eyes, cheeks, nose, mouth, jaw, chin, neck and body.

STAGE FOUR Then, paint in the background in a general value of gray, using black and white greatly thinned with turpentine, plus the color that you have decided for your background. This wash of tone will record your decision of the tone of the background but will not be the completed version of the background; at this point it is just a way to sculpt out the silhouette of the model.

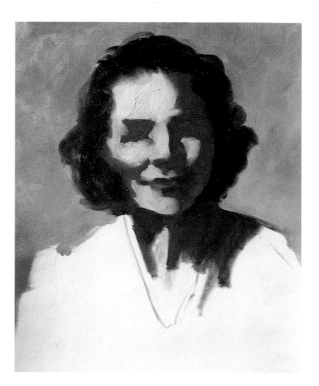

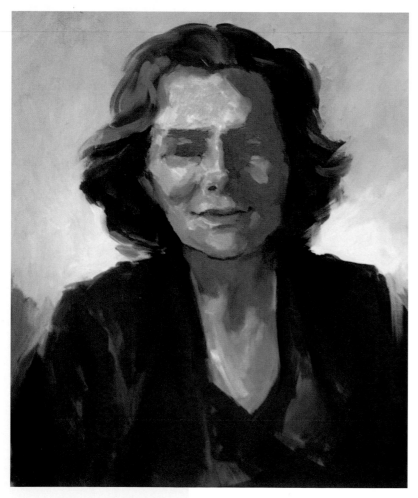

STAGE FIVE I hardly think that any of you will get through steps 1 and 2 without the need to correct the shapes of the light and dark patterns. Correct the shape of the light tones with a small Turkish cloth that's been wetted with turpentine, wiping away wherever the shadow pattern has invaded the illuminated planes. With the shadow color, or the background wash tone, make the corrections you need as these two values meet the illuminated planes. The light tone of the canvas now should represent the areas that are illuminated. The background has been done, the red dress painted, and more definition in the face has been added.

The finished painting. **Audrey Ockenga,** *20" x 24", oil on canvas.* A two-hour painting demonstration in my studio before an audience of students.

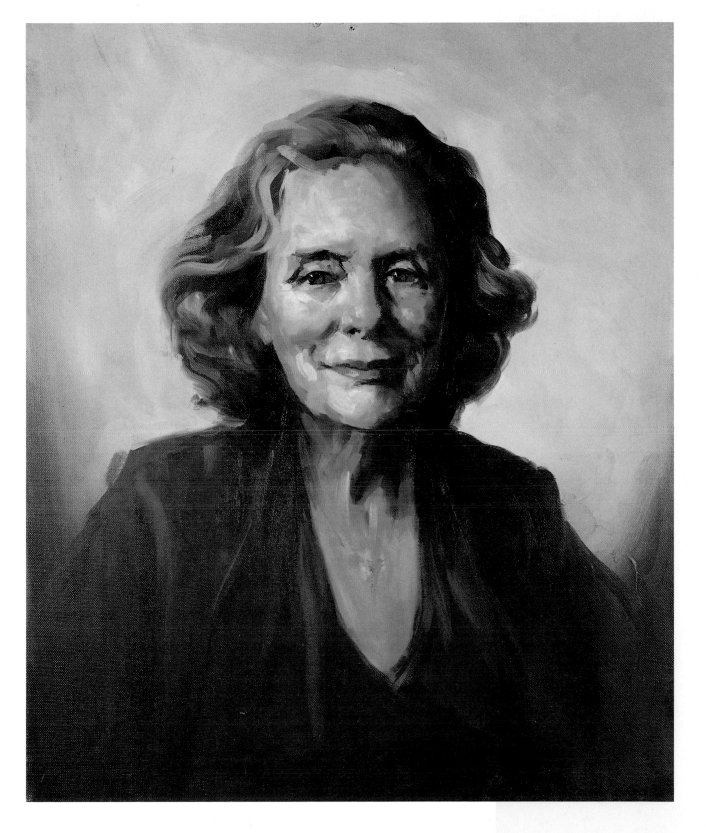

My Palette of Colors

❧❧❧

White is the most essential paint on your palette because all light colors for flesh are mixed into it. I prefer Zinc White, which keeps the flesh mixtures fresh and clean; it doesn't saturate colors as much as the stronger whites do. No matter what white you choose to use, make sure that it's more juicy than it is stiff. A juicier consistency will enable you to mix color into it easily and quickly, which is important to keeping your flesh mixtures lively.

The Warm Colors

Bright Yellows: *Cadmium Yellow Light and Cadmium Yellow Medium.* Since these yellows are used sparingly, don't squeeze out very much of them. Their strong tinting property makes a little go a long way. When they are mixed with a red and white, they make bright versions of flesh color. Mix these yellows with tones of gray for the muted greens that are so often seen on the edges of shadows on the face.

Bright Orange: *Cadmium Orange* is used to add more color into a flesh mixture that is always made of a red and yellow mixed into white. When mixed with black, white and Sap Green, Cadmium Orange makes a lovely warm gray, a color that's seen in the shadowed areas around the mouth.

Bright Reds: *Cadmium Red Light and Grumbacher Red.* For a basic flesh color, mix Cadmium Red Light with Yellow Ochre and white. For the pinks that are often seen in the cheeks and lips, add Grumbacher Red to the basic flesh color.

Duller Yellows: *Yellow Ochre and Raw Sienna.* Each of these yellows when mixed with reds and white will make flesh colors. Squeeze out more of these colors than you would the Cadmium Yellows inasmuch as Yellow Ochre and Raw Sienna are not strong colors. Mix either of them with white for blonde hair, and with light gray for gray hair. Mix either of them with white for white collars and white clothing.

Duller Reds: *Light Red or Venetian Red.* One of these reds is important to have on your palette. A little goes a long way because these reds are strong. Mix either one of them with yellows and white for flesh. When mixed with Raw Sienna or Burnt Umber and gray, it's invaluable for flesh color in shadow. Use either of these reds with Burnt Umber for the darkest darks that are seen in the nostrils, ears and corners of the mouth. These reds can also be used for the redder hues on the nose and on the lips. Light Red is also called English Red Light and should never be confused with Cadmium Red Light.

Dark, Dull Yellows: *Raw Umber, Burnt Umber.* Mix either one with gray for warm gray tones

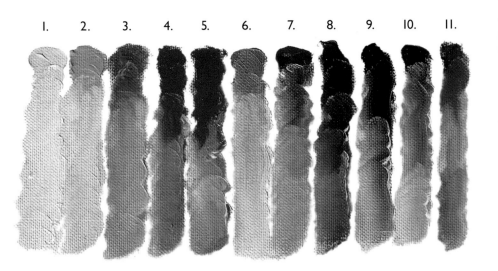

that will be relatively cooler than the warmer flesh mixtures, and use this mixture for the edges of shadows. Or mix it into the flesh color wherever you see very grayed flesh. Since many colors of hair are in the brown family, these dark, dull yellows are indispensable, especially Burnt Umber. These colors are also used to paint dark, warm backgrounds. They are also necessary for painting dark-skinned people and are very useful in shadow mixtures.

Important: Don't mistake these colors as sources of darkness. If you use them to darken areas you'll end up with what is commonly referred to as "muddy color."

Dark, Dull Orange: *Burnt Sienna*'s use is much like Burnt Umber. Burnt Sienna is lighter and brighter than Burnt Umber, and it can impart lively, darker accents when mixed into flesh. For a basic shadow on flesh, mix Burnt Sienna with Sap Green and gray.

Dull Reds: *Indian Red or Mars Violet* are useful for painting warm areas of backgrounds. Mix either one of them with gray for the somewhat cool, dull pinks that are seen in the reflections in the shadowed flesh.

General comment about all the warm colors: Mixing a combination of these warm colors into white makes flesh colors. When they are mixed into gray, or grayed with cool colors, they make shadowed flesh colors.

The Cool Colors

Violets: *Alizarin Crimson and Manganese Violet.* Mix either one into white and yellow for the cooler color of the highlights on flesh. Mix either one with gray for the cool turning edge of shadows. Mix them into a very light gray for highlights on almost any hair color. Mix into Burnt Umber for very warm, dark accents. You must think

Flesh colors are warm colors mixed into white and, usually, are a combination of a red and a yellow. Here are the warm colors of my palette tinted with white. Knowledge of the basic principles of color mixing can direct you to paint an acceptable presentation of color, but true color mixing results from actually looking at colors and responding to their appearance in relation to each.

Reading from left to right, these warm colors are:

1. Cadmium Yellow Light
2. Cadmium Yellow Medium
3. Cadmium Orange
4. Cadmium Red Light
5. Grumbacher Red
6. Yellow Ochre
7. Raw Sienna
8. Light Red
9. Burnt Umber
10. Burnt Sienna
11. Alizarin Crimson

The many mixtures shown here will acquaint you with their capabilities.

How I arrange colors on my palette. Here are the colors that I use, in the order they are lined up on my palette. Since I'm left-handed, I squeeze out the colors from right (white) to left (black). Right handers just do the reverse. The colors on this palette can be identi-fied, looking at them from right to left, as the following:

Zinc White
Thalo Yellow Green
Cadmium Yellow Light
Cadmium Yellow Medium
Cadmium Orange
Cadmium Red Light
Grumbacher Red
Alizarin Crimson
Yellow Ochre
Raw Sienna
Light Red
Burnt Umber
Burnt Sienna
Indian Red
Thalo Blue
Manganese Violet
Sap Green
Thalo Green
Ivory Black

of Alizarin Crimson as a violet. When it's mistaken for a red, some awful mixtures can result; this is best described as a bruised look. You can add Alizarin Crimson to another red (such as Venetian Red, Cadmium Red Light or Grumbacher Red) to darken it, but it can't be used as a red alone. Alizarin Crimson is mostly used in tones of gray for the many violets that are needed for shadowed areas, for hair, clothing and backgrounds.

Blues: *Thalo Blue and Payne's Gray.* Thalo Blue is the most intense, darkest blue you can buy. Don't squeeze out much, it's an extremely strong color. Payne's Gray, on the other hand, is a very low intensity

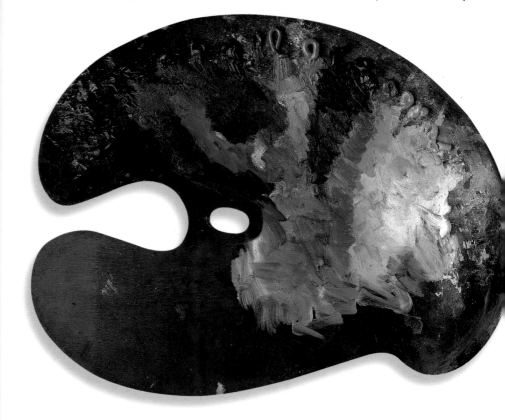

The photograph of the palette shows where to squeeze out your colors and indicates the relative amount of each color that is the most practical to set out for a portrait painting session. Notice how the colors are arranged: a little in from the top edge and from both ends. This keeps the paint a safe distance from accidental smears on clothing, models, furniture, and all other items where paint shouldn't be. It's much easier to use a palette if you squeeze your colors out close together from side to side. This arrangement leaves lots of mixing space, which, for the sake of impact in the photograph, I've covered with colorful mixtures. In reality, I keep this mixing area meticulously clean, wiping it frequently. Think of your palette as a piano with keys next to each other. When a pianist needs a lot of sound from a note, he hits it hard. If you want a lot of color, pick up a lot of that color with your brush.

blue and has a fragile tinting strength. But this doesn't mean that you have to squeeze out more of it than you would Thalo Blue, because your use of Payne's Gray will be limited. Mix either one into Burnt Umber for shadows on brown hair. Mix with black and white and a touch of Burnt Umber for the cool edges of the shadow in flesh. Mix with large amounts of gray for cool backgrounds.

Greens: *Thalo Green, Sap Green and Thalo Yellow Green.* Thalo Green is dark and intense and should be used sparingly. Mix it with gray and any red for lovely cool grays for backgrounds. Add a touch of Thalo Green to any dark warm mixture of flesh to mute it enough to make the mixture more suitable for shadows on flesh. Sap Green is an easier green to deal with since it is not as dark as Thalo Green and is reduced in intensity. Sap Green is handy to have for background colors. Mix it with Manganese Violet and gray for an extremely lovely background color. Mix a touch of it into flesh for grayed flesh areas. Thalo Yellow Green is more a yellow than a green and can be used nicely in flesh mixtures.

General comment about all the cool colors: All these cool colors are often needed in clothing and are used to shadow warm colors. Since cool colors show off warm colors by contrast, the backgrounds of portraits are usually cool.

Black: Ivory Black, when mixed with amounts of white, makes many tones of gray from very light to very dark. You can add color into these tones to make colored grays: Add any of the warm colors for warm grays; add any of the cool colors for cool grays. Beautiful neutral grays are made by mixing a color and its complement — such as Thalo Blue and Burnt Umber — into tones of gray that are made of Ivory Black and white. The tone value of a color is its most important factor, and should be determined first when mixing color. If a color is seen as light and bright, it will need to be mixed with white. If the color is seen as dark and muted, it can be made by mixing it with a

tone of gray. Don't be afraid to use black just because someone told you not to. You can do without it, of course, but it will make your color mixing more difficult, and doesn't color mixing give you enough trouble as it is? Those who say you can't use black because black isn't a color, shouldn't be using white, either, for the very same reason.

Final comment about my palette of colors: These, then, are the colors that make up my palette. I need no more but could get along with less. The minimum palette of colors is white, Cadmium Yellow Light, Cadmium Red Light, Yellow Ochre, Light Red, Burnt Umber, Thalo Blue, Alizarin Crimson and Ivory Black. My complete palette of colors makes the difficulties of color mixing easier. I truly believe that the only way to be able to paint well is to recognize how really difficult it is. This realization challenges my ingenuity, activates a practical approach, and makes me respect adequate, well-organized working materials.

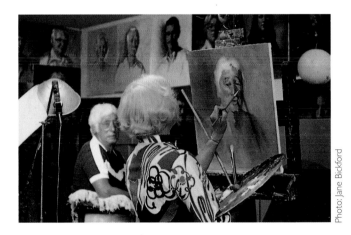

Photo: Jane Bickford

I couldn't think of working at my easel without holding my palette, which may seem awkward at first, but it really makes the entire painting process more efficient. The palette, held close to the painting, makes color and tonal comparison much easier. During a lot of my painting, I just hold my mahl stick in my hand where it serves the same function as Linus's blanket does — it's my security. When I need my mahl stick, I use it to steady my hand.

Painting Materials and Their Uses

Brushes

In these times, buying brushes that are suitable can be very confusing. Added to the variety of natural hair brushes that we've had around for centuries, is the glut of synthetic brushes, most of which are designed to simulate red sable and white bristle. The reason why synthetic brushes have been made, certainly, is their low cost in relation to brushes that are made of natural hair. When you consider, however, how long red sable and white bristle brushes will last, and, more importantly, how much satisfaction you'll get from painting with them, their cost becomes incidental. Of course, there is no brush that will live long if it's neglected or misused. After you've used your brushes, rinse them out in a generous amount of turpentine or paint thinner. Then, with liquid detergent and some warm water in a coffee can (or a large container like it), shampoo your brushes by using an action that's much like mixing cake batter. Finally, rinse off all the lather, shape the brush back into shape and set upright for it to dry.

Proper use of brushes is an easy formula: big jobs, big brushes; little jobs, little brushes. The beginning stages of a painting entail broad applications of large areas, and the gradual refinement toward a finished picture makes each application smaller. Start with a big brush and end up with a little one, or, to put it another way, start with a broom and finish with a needle. The following are the natural hair brushes that I use and recommend:

- **Red sable Bright.** A chisel-edged brush for the general painting of the flesh tones in light and shade. Sizes 10 to 16. For refining the shapes and tones of the shadows and edges of the shadows, use sizes 4 to 10.

- **White bristle filbert.** A flat ferruled brush that becomes rounded at its end for the initial lay-in of the composition and the patterns of light and dark. Also for painting clothing and backgrounds. Sizes 9 to 12.

- **Red sable filbert.** For the darker accents in the shadows. Sizes 2 to 6. You can also use a red sable Bright for this.

- **Hake.** Made in Japan, this brush (pronounced hockey) is for blending backgrounds and clothing. Get large sizes only. Any large red sable brush can also be used to fuse two tones together. **Important:** any brush that you use as a blender has to be perfectly dry and free of any paint.

My portrait of Laura Stover serves as the background to illustrate how I used various brushes to paint specific areas.

Size 10 Red Sable Bright: Good for painting flesh areas.

Size 8 White Bristle Filbert: A good workhorse brush.

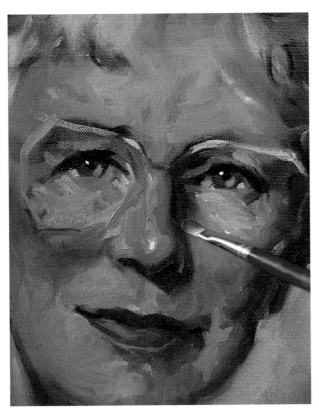

Size 5 Red Sable Filbert: For smaller shaped tones.

Large sized Hake: For blending in areas to enable restatement with stronger contrasts.

A Palette

I recommend a palette that's light enough to hold. Your palette should be as close at hand as possible because so many variations of color have to be fitted together in such small shapes. I always hold my palette when I work on the face, but I will set it down on a nearby table when I'm painting the background and clothing. The portrait painter's palette should be toned medium dark so flesh mixtures will look light against it. If you mix flesh tones on a light-colored surface, they'll look dark in relation to it which will then tempt you to use too much white in your flesh mixtures, resulting in a chalky tone that makes highlighting virtually impossible. On this note, here's an emphatic "no-no": **Never, never, never use strip-off paper palettes!** The reason is the one I've just stated above. The penalty for any student bringing one to class is banishment forever.

Turpentine and Paint Thinners

I use turpentine as a medium for the first sitting and to clean my brushes between mixtures. The high cost of turpentine, and, to many, its offensive odor, has made a number of artists start to use paint thinners. There are ones on the market that are odorless, and generally the price of thinners is a mere fraction of that of turpentine. Paint thinners are fine for cleaning brushes between mixtures and, of course, for final cleanup, but never use any thinner to make a painting medium. Only the finest turpentine will do for this purpose.

A Medium

I make my medium of equal parts of turpentine, linseed oil and damar varnish. I use this medium to thin the subsequent applications of paint after the first sitting. When your portrait is finished and dry to the touch, use damar varnish to impart an advantageous shine to the colors.

Rags

Even though rags are not items that are manufactured by art supply companies, I think of them as painting materials. The role they play in cleaning up is obvious. Their major function is in the actual painting process. I hold a rag in my non-painting hand all the time that I work. I need a rag to wipe away mistakes (never paint over them), to soak up turpentine that's still left in the brush after cleaning it from color to color, and to help me regulate the amount of paint on the brush for various applications. When I mix a color on my palette, my only concern is its tone, hue and intensity not its application to the canvas. Once this is established, the paint on the brush has to be reconsidered so that it can be applied to record the particular shape in question. To do this I wipe the brush on the rag and reload it with the amount of the mixture that I think will paint the shape. I guess you can call a rag your brush's co-star. What's the best rag to use? Turkish toweling cut into six-inch squares.

Important Notice: This book's primary purpose is to teach you how to paint portraits. It is not about the technical aspects of oil painting. If you feel that you need information about varnishing, permanency, paint surface appearance — shiny or dull — or other characteristics of oil paint, I suggest that you read books that deal with that phase of the oil paint medium. *The Artist's Handbook* by Ralph Mayer is one I recommend. You will also find some information in this area, perhaps not as detailed, in my book, *Your Painting Questions Answered from A to Z*. These books will answer all the technical questions that seem to baffle many students of oil painting. The use of oil paint, as taught in this book, is simple but sound. It is based on a correct understanding of the structure of oil painting and has the corroboration of my many years of experience.

I can concentrate better and work more efficiently in an uncluttered studio. I do this by keeping all my supplies in another room, bringing to my studio only those materials that I need for each painting session. Everyone has his own temperament and his own way of working. Professional painters that I've met are always well organized and comparatively neat in their working habits. Things can get messed up while I paint, but I've disciplined myself to clean up after each painting session. This cleanup is necessary for the pleasure of future painting times. Pictured in the inset is a painting I did of the only materials you should have on your painting table.

The Color Mixtures for the 5 Basic Tones of Flesh

❦❧

The Body Tones of Flesh

Body tone is the term I use to describe the light tones of flesh. Body tones are seen where the features are illuminated by the light. To mix the colors of the body tone, add any of the warm colors into white. This is a color mixing formula that's broad enough to apply to any type of skin coloring, from very pale skin to the skin of black people. It also applies to men, women and children.

To be able to paint the many variations of the body tone, move a gob of white (about half a jigger) to a mixing area of your palette. Into this you can mix combinations of yellows, oranges and reds to paint the coloring of the forehead, cheeks, nose, chin, lips and neck. The more little variations of color that you observe and include in these areas, the more the skin color will look alive. I'd like you to reread Chapter 6, "My Palette of Colors," for specific mixtures. The other chapters on procedure also suggest color mixtures. Throughout this book you'll consistently find this reliable formula: *Flesh colors are any warm colors into white.*

The instruction about color mixing that is worth repeating is: flesh mixtures should be quickly mixed to maintain the vibrancy that results from lightly admixed colors. Also important: when mixing light flesh colors mix more than you think you need. If you can see the color of your palette through the paint mixture then you know that your mixture is too thin and too skimpy to be effective to record a body tone.

The Highlights on Flesh

Highlights on the flesh colors of the body tone make the skin shine and glow. These are recorded with lighter, relatively cooler flesh colors. To paint highlights correctly, it's important to recognize and understand how and why some colors are relatively cooler or warmer than others. To explain this color factor, let's start with the most obvious warm and cool color relationship, that of warm orange and cool blue. Of the three warm colors — yellow, orange and red — orange is the warmest, because of orange's hue tendency; it can only tip toward yellow or red, which are also warm colors. The hues of red and yellow, on the other hand, can tend toward cool colors: red toward violet; yellow toward green. This is what makes yellows and reds relatively cooler than orange. Of the two, red is cooler than yellow because red's hue of violet is a cooler color than yellow's hue of green. All this may sound like "Who's on first" but it does explain why highlights that are made of light tones of pink reds into white are relatively cooler than flesh mixtures that are predominantly tones of

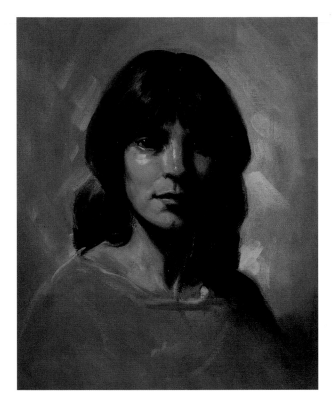

orange. Make highlights on flesh by mixing a touch of Alizarin Crimson and a touch of Cadmium Yellow Light into a gob of white. Or just mix Cadmium Red Light into a lot of white.

The Body Shadows of Flesh

Shadowed flesh tones are darker, duller versions of warm flesh colors. Mix these tones by adding any of the warm colors on the palette to a gray that's been made of black, white and a touch of one of the cool colors — violet, blue or green.

It stands to reason that if warm color that's mixed into white makes the light tones of flesh, then warm color that's mixed into gray makes shadowed flesh color since gray is shadowed white. This may sound like "What's on second" but it works. Some shadowed flesh mixtures are:

- ✤ Black, white, Sap Green, Yellow Ochre and Light Red.
- ✤ Black, white, Alizarin Crimson and Raw Sienna.
- ✤ Black, white, Thalo Blue and Burnt Sienna.
- ✤ Black, white, Raw Sienna and Cadmium Red Light.

The black-and-white mixture establishes the tone of the shadow; the colors that are added into it color that tone. How colorful you want the shadow to be is determined by the kind of lighting you use and also the model's surroundings.

All the color mixtures that I used to paint my niece, Debbie Kee, are pictured here. Light flesh colors for the body tones with cool lighter highlights. Cool gray for the edges of the shadows, darker flesh mixtures for the shadows and some darker cool colors for accents.

Debbie, her husband Ed and their two daughters would come to Rockport every summer to visit. It was during one of their vacations from their Delaware home, that I had Debbie pose for me. She is such a pretty young woman who made a marvelous model. Many of my best portrait sketches were painted of family and friends who were over as household or just dinner guests. You'll find out more about this in Chapter 27, *Painting Your Family.*

It's important to identify the tone value you are working on so you can know basically what color to use. Here's how, in my portrait of Herb's daughter, Leslie:

1. A Highlight on brown hair: Gray violet, complementary to the hair.

2. A Highlight on flesh: A cool, light mixture.

3. A cast shadow from the nose: Darker, cooler shadow than a body shadow.

4. A body shadow: Darker flesh colors.

5. A turning edge: A cooler color.

6. A shadow on the hair: Hair color with the complementary blue.

7. Body tone: Flesh colors into white.

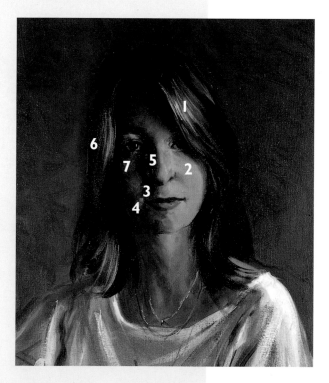

The Edge of the Shadow

Where the body tone and body shadow meet is the area that I call the turning edge. I'm sure that many of you may want to call it the cursed edge because it's so difficult to paint. The turning edge is where you have to make a light flesh tone disappear into shadow. Its shape must describe the form it happens to fall on. To make body flesh color disappear into shadow, its color has to be diminished. Do this with the warm flesh color's complement, which is any cool color. Once this cool color blends the flesh color into shadow, the actual shadow color shows up. Here are some color mixtures for the turning edge:

- Black, white, Thalo Blue and a touch of Burnt Umber.
- Black, white, Alizarin Crimson and a touch of Sap Green.
- Black, white, Sap Green and a touch of Manganese Violet or, generally, any mixture that looks cool in relation to flesh color.

Reflections

Reflections are tones in shadows that are caused by light bouncing off nearby objects, such as clothing or the background. They are always lighter than the shadow tone but not as light as the body tone. Reflections can also be caused by lights in the room other than the main source of light that determines the body tones. Reflections are said to be conditional colors because their colors reflect the conditions that cause them. Mix these colors by adding white to make the reflections the lighter tone that you see in the shadow. Don't be misled by its seemingly light look; a reflection always looks lighter than it really is. Since it is being placed, seen and compared to in a dark area, its relative tone can be mistaken. Test the tone of the reflection's color mixture by putting a bit of it on your palette next to the body tone mixture. To be correct, it must be darker than the body tone mixtures. Reflections play an important role in the overall three dimensional effect. If reflections are too light, dimension will be lost rather than gained.

Cast Shadows

The darker shadow tones that are seen most often on the underplanes of the features — under the eyelids, under the nose, under the chin and on the lower lip from the upper lip — are cast shadows.

Mix the color of these important darker shadows by adding Alizarin Crimson and a touch of Thalo Blue into the body shadow mixture.

The edges of cast shadows are cooler colors, as are the edges of body shadows. Once the cast shadow shapes are established with the darker cool mixture, mix a warm color into the cast shadow color. This warm color can be Burnt Umber, Venetian Red or Burnt Sienna. Paint it into the interior of the cast shadow shape.

Final Comment: Mistakes in mixing flesh colors are usually mistakes of tone instead of mistakes of color. To accurately judge and record the tones of flesh colors, think of color and color mixing in the following way:

- The light side is where light flesh colors are and the dark shadow side is where dark flesh colors are. No tone in the light side is seen in the dark side and no dark tone is seen in the light side.

- On your palette, establish an area for all the light flesh mixtures and one for dark flesh mixtures, and never dip from one into the other.

Portrait Painting Color Mixing Pointers

1. Your flesh colors will look luminous if you put relatively warm colors next to cool colors.

2. Flesh colors in light have to be saturated with white.

3. Colors in shadow have to be diminished with gray.

4. Don't confuse the body shadow with reflections. The body shadow is the color of the shadow; the reflections are lighter colors in body shadows.

5. Make duller flesh colors in the body tone by adding duller warm colors, such as Burnt Umber or Burnt Sienna. Since these duller colors are darker as well as duller, the mixture will need to be lightened with more white. You'll find these duller flesh colors in the bearded areas of men, around the hair line and around the temples and lower eye sockets.

6. Make the lower lip color by adding into the flesh color any of these reds: Cadmium Red Light, Venetian Red, Alizarin Crimson or Grumbacher Red. Remember, the lower lip is always almost as light as the flesh tones.

7. Paint the eyebrows in a gray and add the color of them on top of the gray. The eyebrow area is as much a shadow tone as it is hair.

8. Paint your flesh colors initially with a lot of variations of hue. The smooth look of the skin can be then obtained by blending all the varying hues together. Painting flesh this way makes the skin look more alive. Smoothing out the colors of flesh as you paint them makes the skin look flat, leathery and dead.

9. Don't make your basic flesh tone mixture so light that you can't add lighter tones for the highlights.

10. Don't be afraid to make the initial pattern of the shadow dark. You can always add reflected color into a dark shadow.

11. The flesh colors of the body tone are applied with very little thinning of the paint.

12. The shadowed flesh can be thinner mixtures.

13. Make the whites of the eyes by adding more white and some Burnt Umber into the flesh mixture.

14. The color quality of flesh tone is mostly a result of grayed color that's dispersed with the more clear flesh colors. Don't be afraid of using tiny drops of Ivory Black to lessen a flesh color's intensity. After all, Ivory Black is the least intense cool color on your palette. A muddy look doesn't come from using black; it comes from using browns to darken colors and by using only warm colors.

Chapter 9

The Tone
of the Shadow

I've always wondered why students get so involved with the color of the shadows on the features. The real difficulty with painting the body shadows is their tone and shape not their color. A shadow's coloration is really quite simple: Its edge is a cool gray and its color is gray into dark flesh color.

The tone of the body shadows varies according to the degree of reflected light in them. When there is a lot of reflected light, the body shadow itself is lighter than its turning edge. With little reflected light, the shadow is darker than the turning edge. You can control the degree of light in shadows by moving a light backdrop either closer or farther from the model on his shadow side. In my studio, I have three large mat boards: One light gray, one medium gray, one dark gray. To see how each tone influences the shadow on my model's face, I place each board, one by one, on an easel near the model's shadow side to see the tonal

influence on the shadow. These tones will only influence the color and tone of the body of the shadow; they will not move or change the color of the turning edge.

The reflected light in shadow that causes color to appear should not be confused with reflections. Reflected light in shadows is caused by a general condition in the room. My three mat boards give me a way to experiment with this condition and then judge which would be more suitable. Reflections, on the other hand, are caused by more distinctive and immediate influences, such as a white collar reflecting back into the shadow. To clarify further, reflected light puts color back into a shadow, leaving the grayness of shadowed areas only on its edge — the turning point.

Finally, no matter what you add into a shadow, never, never, never add a tone that's anywhere similar to a tone of the body tone.

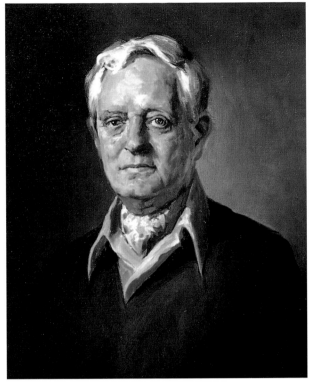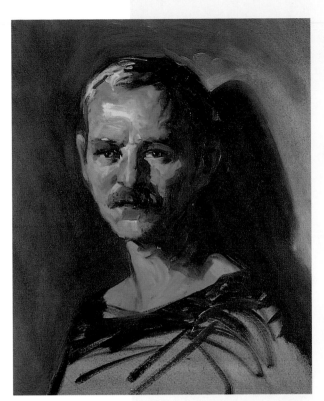

These portraits were done with lighting from the left. More reflective light influenced the shadow on the portrait of Henry Bucci (left). See how much lighter the shadow is. Hardly any reflective lighting was used on the shadow side of the portrait of John Hurley (right). The question "when to use what light?" can't be answered. It's a matter of taste.

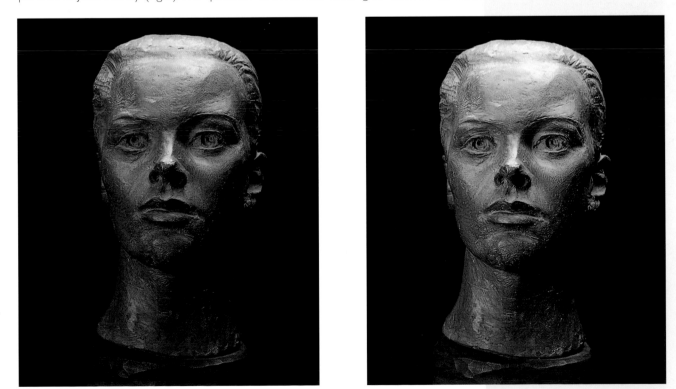

I used this bust of me that was sculpted many years ago by my friend, Domenico Facci, to illustrate desirable lighting for a model. The one on the left has no reflective lighting while the one on the right has some. The tone of the background will contribute a strong influence on the reflected light in shadows. Very dark backgrounds make reflected light more obvious.

The Decorative Quality of Reflections

Reflections are beautiful lighter tones that are often seen in shadows. They add intrigue and beauty to shadows. Reflections are often painted with passion instead of with discretion.

The tone of reflections, in relation to all the other tones, can be difficult to recognize correctly. Reflections only look light since they are surrounded by dark tones. One way to keep reflections in their tonal place is to always mix the color of the reflection into a tone of gray, or into the body shadow color.

Reflections in shadows can suggest an interesting characteristic to the model. The cool reflections in the shadow area on the portrait of Gabrielle Viator, a precocious nine when I painted her, impart a cool, clean serenity. I felt that these cool reflections harmonized her face with her white blouse. Since reflections are the least structural of the five tone values, it is not essential that you paint them. It's more a matter of taste than necessity. If you do choose to paint reflections, always make them additions to an already painted shadow. They are a finishing touch.

It's difficult for a student to see a model's face in terms of planes. The student's mind is usually on getting a likeness, not realizing that the likeness is embedded in the planes. A plaster cast of the planes of the face is often used by art instructors to make students aware of the importance of the planes. Since it's more convincing to show the planes on an actual portrait, let me direct your attention to my painting of Gabrielle. The reflections single out the planes on the right side of her head (as we look at the picture) which are greatly narrowed in relation to the corresponding planes on the left side. This is due to the perspective at which the model was viewed. Now, carefully study Gabrielle's portrait and see the symmetry and organization of the tones on the face's planes. The front plane of the face is light on the left (as we look at it) and in shadow on the right. The shadowed right side is influenced by reflections where the side planes of the face, nose and mouth are seen. The left side planes are enhanced with lighter tones where the left side planes are seen. Be ever conscious of the face and its features, their front, side and underplanes.

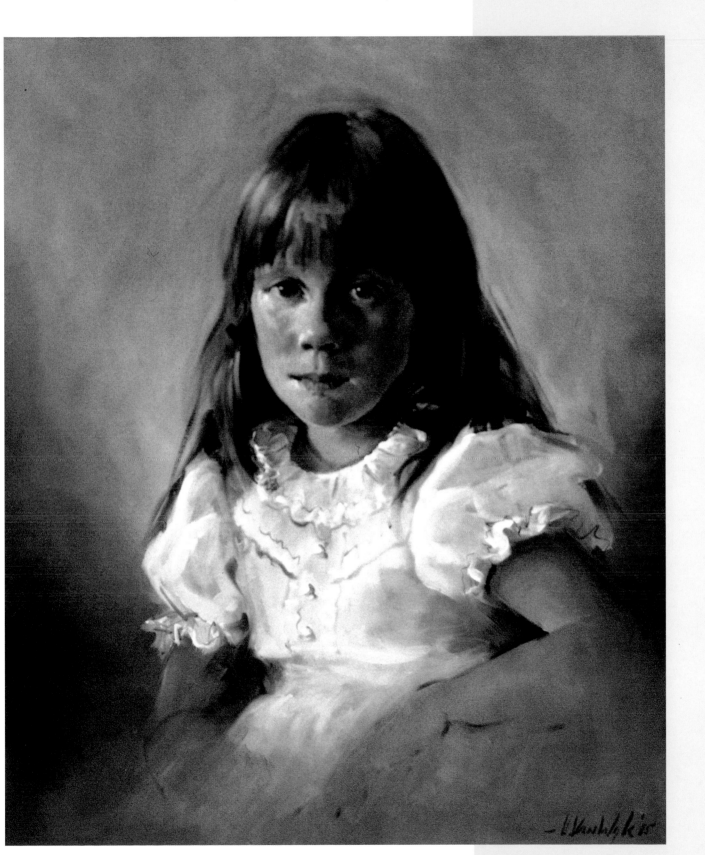

Gabrielle Viator

A Closer Examination of Cool Colors in Flesh

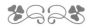

A good likeness of the model's features is an obvious asset to a portrait. Another contribution to a good portrait is flesh color that looks alive. The face should look as though it glows with life. One way the portrait painter can get this look is to accentuate the warm flesh mixtures with cool colors.

By carefully examining the portrait of JoAnn Gleason, you will see where cool colors were used. First, look at the lightest tones in the flesh area; they are relatively cooler flesh colors than the ones that surround them. These are the all-important highlights that show up on the concave and convex planes that are directly in line with the source of light. What follows is a good highlight color mixture:

❧ Move a sizable amount of white into a mixing area of the palette, and add a touch of Alizarin Crimson. Then, to reduce the harsh pale violet that results from mixing Alizarin Crimson with white, carefully add some Cadmium Yellow Light (or Cadmium Yellow Medium) to the mixture.

Cool colors also appear where the flesh color falls away into shadow. Notice, on the portrait, the small area of color between the light flesh color and dark shadow color. This cool, darker tone is called the turning edge. It's a difficult area to paint. The subtle blending of the contrasting tones, while trying to record its correct shape, takes times and patience. The fact that cool color must be used to turn the light flesh color into dark shadow adds its complication to this painting maneuver. But this is a color factor in painting that can't be denied and must be learned, much like having to learn scales in music and grammar in writing:

❧ The mixtures for these turning edges are varied, but a basic way to mix them is to add some Ivory Black into a basic flesh mixture (white, Yellow Ochre and Venetian Red or Light Red) and then add any cool color — violet, blue or green. Cool colors that are suitable to use are: Sap Green, Payne's Gray and Manganese Violet. You can also use the more intense cool colors such as Thalo Blue, Thalo Green and Alizarin Crimson. But use them sparingly.

To help you identify these cool areas, I've marked up two photographs of progressive steps taken in the course of painting JoAnn's portrait. In one, all the highlight areas are encircled; in the other, all the turning edges are outlined.

The circled areas on JoAnn's face in this early stage of the portrait represent where the highlights will be. The cooler, lighter tone value of a highlight is always seen on concave and convex planes that are directly in line with the source of light. The addition of highlights adds a glow to the skin tone. Don't ever mistake this lovely glow on the skin as a basic flesh mixture. A common mistake of beginners is to start painting the flesh area with a tone that's too light only to find out that they then can't add a highlight to this already too-light tone. As you can see in this stage of the painting, the flesh tones are such that they can take lighter lights, ending with the lightest tones of all — the highlights. Of course, the adding of highlights at this stage of the painting is premature. Check this stage with the finished painting.

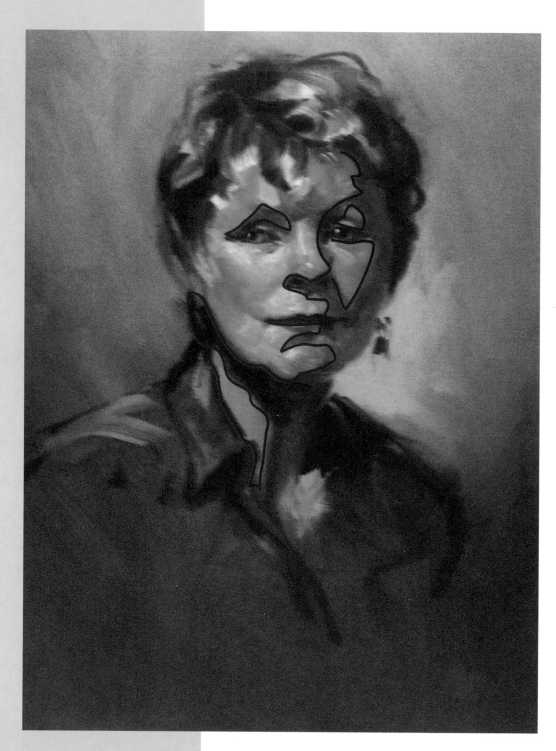

STAGE TWO The outlined areas on another stage in the portrait of JoAnn show the turning edges on her face which are always found on the corner of two planes and on the edges of cast shadows. They are called turning edges (or turning points) because these are where the light can no longer illuminate the plane that it's shining on. The outer edge of a cast shadow is the point where the lighting is robbed of shining because of the feature in its path. Since there is virtually no light on turning edges, there is no color that is visible. Using a dark cool color to blend the flesh color into shadow, the flesh color is grayed as well as darkened. Reflected light then can make color appear inside the shadows. The turning edges in this progressive step of the portrait are already in evidence. Compare this step with the finished painting.

STAGE
THREE
My portrait study of JoAnn is an excellent example of a rendering of the warm and cool colors on a face. It is a looser interpretation of the colors of flesh. You will become more accomplished as a portrait painter by doing many practice studies. Rembrandt, it's interesting to note, painted himself more than seventy times. If that number of practice studies was good enough for the greatest portrait painter of all time, you surely can invest some of your time for the same kind of practice studies. Keep in mind that no matter how you interpret the portrait you paint, the principles of painting flesh are the same.

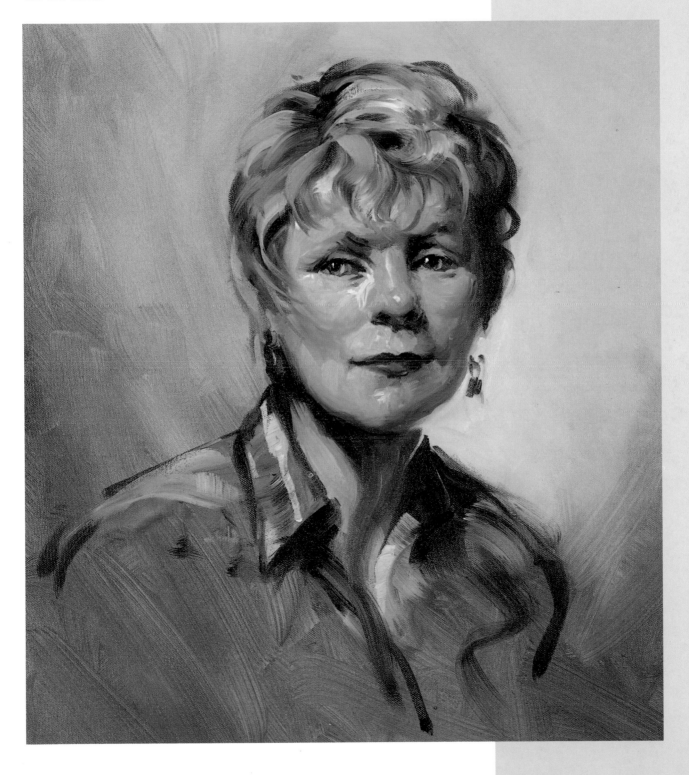

The Colors of Dark-Skinned People

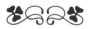

Your paint can only make an image show up by fitting together shapes of contrasting tones. Painting the skin of non-white people is no exception. It, too, must be recorded with contrasts — light tones of dark skin and dark tones of dark skin.

There are as many variations of complexions in dark-skinned people as there are in white people. My basic formula of warm colors into white for painting all types of skin color, also applies to black and dark-skinned people. The adjustment that makes the formula work for dark skin is that less white is necessary and the use of the darker, less intense warm colors have to predominate.

The dark, warm colors are Burnt Umber, Raw Umber, Burnt Sienna and Indian Red. These colors can be reduced in intensity even more by mixing in some Payne's Gray. Here are basic color mixtures for the five tone values on dark skin:

1. The body skin tone: *Into some white, mix Burnt Umber, Burnt Sienna and a touch of Venetian Red. If this mixture is too bright, add some Payne's Gray.*

2. The body shadow: *Mix some Thalo Green and Alizarin Crimson into the body skin tone.*

3. The dark flesh colors in the shadowed areas: *Burnt Sienna and Burnt Umber. Any reflections into the shadows are dependent upon the conditions that are causing the reflections.*

4. The highlights: *A mixture of white and Manganese Violet.*

5. The cast shadows or darkest darks: *Burnt Umber and Alizarin Crimson cooled with a touch of Thalo Blue.*

The tone of the background of a portrait contributes as much to the look of the skin as the actual colors used to paint the skin. When painting dark-skinned people, a very light background is a good choice so the body tone and body shadow will both be darker by contrast. A medium tone would be too close in tone to the body tone. You can see this clearly in the portrait of the Reverend Richard Owens.

In the portrait sketch of Bonita Valien, I used a darker tone for the background to make the body flesh tones light by contrast. Her complexion is more colorful and lighter than the Reverend Owens.

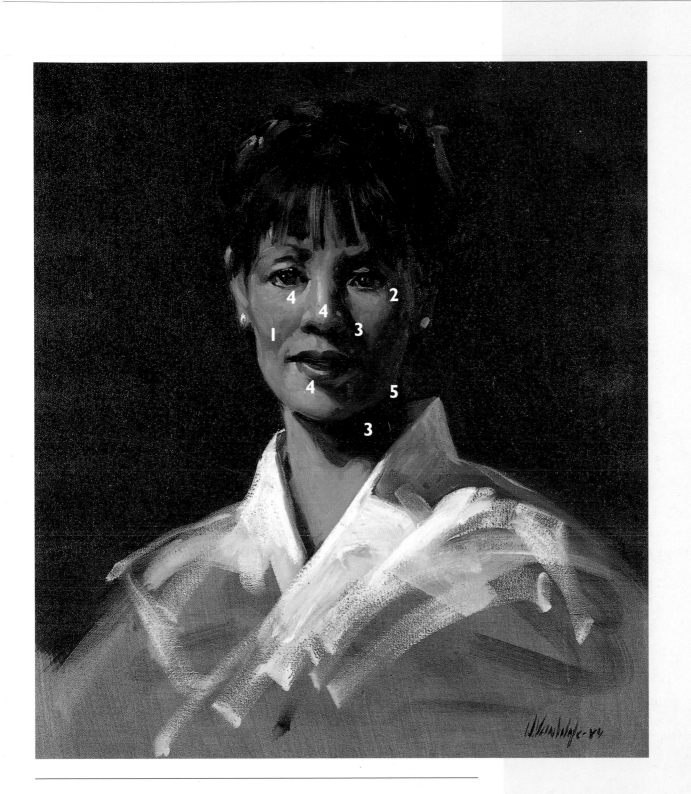

In order to get a three-dimensional look on your two-dimensional surface you must use five tone values. These tone values are seen on all subjects that are influenced by one source of light, whether the subjects are light- or dark-skinned. The following identifies the five tone values on the portrait of my charming Japanese model, Mindori. I've numbered these tones as follows:
1. Body Tone; **2.** Body Shadow; **3.** Cast Shadow; **4.** Highlight; **5.** Reflection.

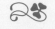

Compared to the colors of the portrait of Bonita, the color mixtures for flesh seem strong and harsh. They truly are. This is due to the fact that color mixtures appear more realistic when they are in juxtaposition with each other on the portrait.

For Your Information

Late in the 1980s, I had decided that I would not teach at the easel any longer. I had been teaching for forty years so I did not arrive at this decision easily. I loved to teach but I was growing disenchanted by students' attitudes toward learning the painting principles. Their emphasis had turned in the direction of sales and prizes.

To replace my practical painting workshops, I implemented seminars that would be made up of lectures, demonstrations and critiques. There would be no painting done by students during their stay in my classes. I realized that the concept of studying painting without actually doing any was risky; would anyone want to sign up for these classes? I managed to fill up the first seminar and was fortunate that Bonita Valien of Washington, D.C., was in that group. Her enthusiasm for this type of study was truly contagious. Some months later, Bonita invited me to Washington to conduct a similar seminar for a filled class of her fellow painters.

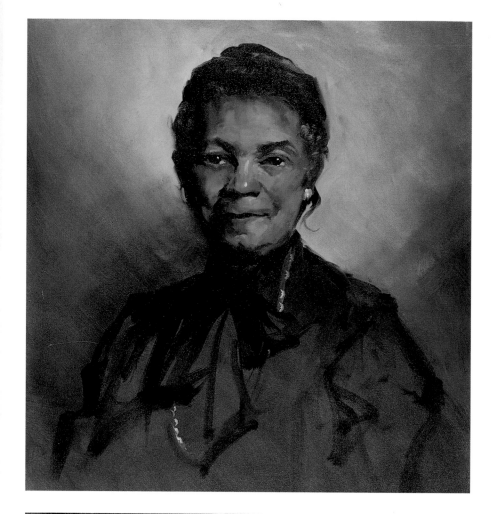

Reverend Richard Owens

Reverend Wesley Roberts

The dark skin of the Reverend Owens provoked a light background. I wanted to show off his dark robe and to present an imposing silhouette. The Reverend Wesley Roberts replaced Dr. Owens, who served his congregation at the People's Baptist Church in Boston for thirty-five years. Although, as you can see, Dr. Roberts is lighter skinned than his predecessor, the procedure I used to paint him involved the same color mixtures.

For Your Information
The unveiling of the Rev. Owens' portrait was the most heart-warming experience of my career. The fee for the portrait was made up of contributions from the church's members. It was to be shown in the congregation after services that memorable Sunday. The portrait rested on an easel under a beautiful blue satin cloth. No one other than Dr. Owens, his wife, and the church's elders, had seen the picture. There were 800 in attendance that day, not unusual for a worship service, I had later learned. When the drape was removed, the huge room was flooded with "Amens" and then applause, followed by the most remarkable part. As all in attendance came by to get a closer look, each and every one shook my hand and thanked me.

Color Mixing in Action – A Portrait Demonstration of my Mother

❧❦❧

In my introduction, I told you how my mother wouldn't pose for my classes any more inasmuch as students made her "look so funny." She has always been an extremely cooperative model whenever I wanted to paint her. For one thing, she knows that I won't make her look "funny." For another thing, being her daughter also helps. When I painted this portrait, my mother was eighty years old. Upon looking at the completed portrait, she said, "I like it. It's pleasant." And then, "Do I look eighty?"

While I was painting my mother, I reminded her of the advice she gave me many, many years ago when I was to marry for the first time, and didn't know how to cook. At that time, she said, "Helen, just start on time and keep the flame low." Good, practical advice which I have applied not only to cooking but to painting as well. Those wise words, along with "even if you have to walk one thousand miles, you still have to do it one step at a time" (not my mother's proverb but one, I believe, coined by some ancient Chinese philosopher) are the foundations of my step-by-step approach to painting.

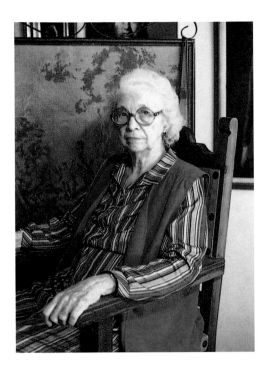

STAGE ONE Her pose. Mother is not the type that suggests a dramatic lighting or pose. I situated her in a comfortable position, with lighting that made soft shadows on her face.

STAGE TWO On a toned canvas, I placed and proportioned the head and boldly indicated the shadow pattern with a gray made of black and white.

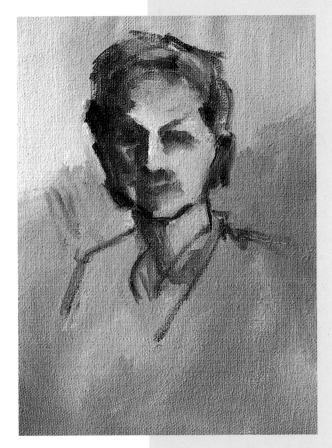

STAGE THREE Into a large amount of white, I added the color that I saw on her face, starting from the forehead and working down to the mouth area. As I painted in the flesh tones, I corrected their shapes with a brush of dark gray that was made of black, white, Sap Green and Alizarin Crimson.

57

FOUR/FIVE

After a short rest (coffee and cookies), I continued laying in the light flesh tones around the mouth, again correcting its shape with contrasting dark gray. Once finished with the laying in of the flesh colors in the body tone area, I gave Mother another rest. I used this time to paint in a tone for the background, cutting it into the shape of her hair and body. When she returned to the model stand, I was able to paint in her hair in two tones (light and dark) and also her red dress, by moving their shapes out and over the background tone.

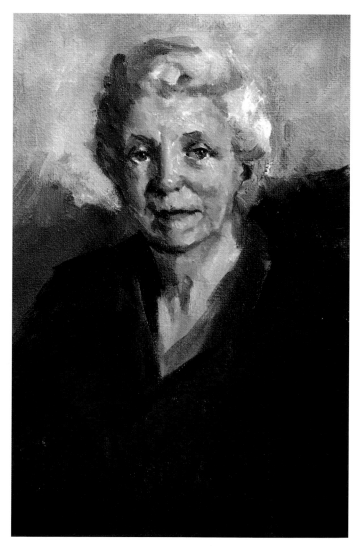

After this stage, I invited Mother to look at the portrait. It was obvious that Mother still remembered her class posing days because she hadn't looked at my progress during her earlier rest periods until I invited her to see the painting. I'm making this point to all of you, because I want to emphasize how important it is to never let your model see the picture until you feel it can be viewed, even when your model is your own mother. Your model's negative or positive reaction will surely influence your progress. A negative reaction, obviously, will make you nervous about having to improve your picture; a positive reaction will make you nervous about possibly wrecking the picture. My advice, then, is to save the "unveiling" until after you have applied the final stroke.

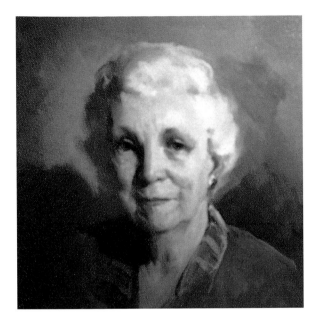

STAGE SIX I always find that I'm free and bold during the first sitting. The second sitting is inhibiting because I now have to relate to what I've already done with the fear of messing up a good start. The first sitting, of course, doesn't present this kind of pressure since I had nothing to lose. But I did need another sitting with Mother to refine what I had accomplished in the first sitting. I did this by first glazing the face area with a very small amount of Cadmium Red Light and Raw Sienna thinned greatly with painting medium. This glaze (transparent color applied on a dry surface) slightly darkened the flesh area and added some color into the gray shadow areas. It also wetted the painted areas, thus making my additions adjust themselves better than if I had worked on a dry surface.

STAGE SEVEN The finished painting. My Mother, **Alida DeBoer,** *16" x 20", oil on canvas.* I armed myself with some smaller brushes and inspected each feature. By adding lighter comments of tone to the light areas and darker accents to the shadows, I zeroed in on the personal characteristics of my mother's features. I also had to mend some of the turning edges with tones of gray. What fun! What a struggle!

Final Comment. Even though my mother wears eyeglasses, I decided to leave them off. It's in the final sitting that you have to paint them in. I felt right then and there that the portrait was a good likeness of her without them. In commission work, show the portrait without the eyeglasses to the model and family, and leave the decision of including them up to them. Once you've painted glasses on the face, it's hard to get them off without ruining the area around the eyes. If they decide that the sitter looks naked without eyeglasses, add them only after the paint on the face has dried somewhat. It's much safer that way. Why create problems for yourself?

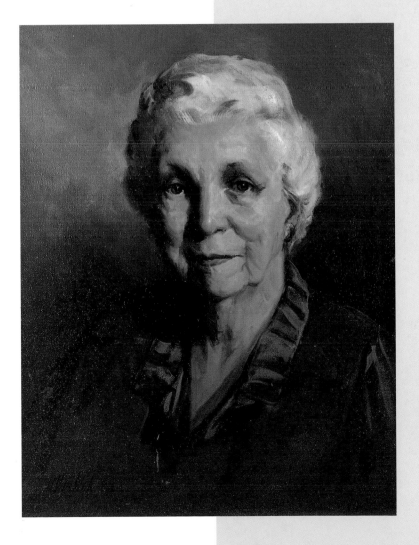

Alla Prima Step-by-Step

Alla prima is an Italian phrase that is loosely translated as "from the beginning" — or "all at once" — and describes, in painting, a direct approach. The excitement of a portrait done *alla prima* is that it looks as though it was done so easily; with such carefree abandon. This is the way beginners want to paint. The accuracy and ease of a successful *alla prima* rendering, however, actually results from discipline and practice. The step-by-step development of a painting I did at a Haverhill, Mass., demonstration illustrates an *alla prima* technique.

To understand the procedure that I used to paint this portrait and, by the way, it is the procedure that I always use, I have to draw your attention to the function of a brush. Many students liken a brush to a pencil. Not so. The two instruments are entirely different. Brushes have been designed to mass in shapes of tone. Pencils have been designed to make lines. The only similarity between the two is that their tips determine the marks they can make: a sharply

pointed pencil makes a sharp line; the sharp end of a brush can sharply chisel in areas of tone. The best way to use a brush is to fit tones together to record accurate shapes of light and dark paint in such a way that one tone cuts down another. You do this most easily and successfully by starting at the top of a form and working down. The body tone of each feature was painted in and then shaped by the next one down, starting at the forehead and ending at the collar of the shirt.

You will be able to see clearly how this is accomplished in the following step-by-step progression of my demonstration painting. I have to point out to you at this juncture that the progressive steps for this demonstration were added much later on. A step-by-step presentation requires the presence of a photographer — or the artist himself — to capture on film each phase of the painting's progress. This was impossible to do in front of the standing-room-only crowd that had gathered to watch me that night.

STAGE ONE After making a rough sketch of the model, I painted a very light tone on each feature wherever there was a highlight. I did this to establish a key of tone for the basic flesh colors. This step shows that I had begun painting the flesh tones in, starting on the forehead. I did it by painting the forehead color out beyond the hair, the shadow on the left and the eyebrows. Then I shaped the forehead by cutting it down to size with the darker shadow tone (a cool gray) on the right and on top of the brows and then with some light strokes of color for the hair.

STAGE TWO Now I've painted the mass tones on the cheeks, starting from the bottom of the shadowed eye area, and extending the tone down into the lower cheek area. At this stage, I fitted the light tones of the nose to the left cheek and then more accurately cut the cast shadow from the nose into the right cheek.

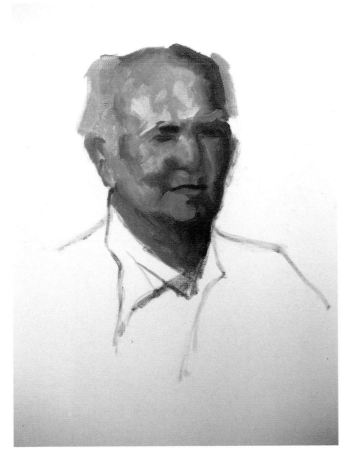

STAGE THREE I fitted the upper lip area to the cheeks, extending it down farther than the actual shape of the upper lip area, and painted the dark of the upper lip of the mouth against that extended shape to cut it down to a correct size. I shaped the upper lip with the light tone of the lower one and then massed in the light tone of the chin. Next, I corrected the shape of the body tone of the chin with the shadow under the chin, and painted the light tone of the neck, repainting the entire shadow. I did this with shadowed flesh color (black, white, Alizarin Crimson — very gray — plus Burnt Umber, Burnt Sienna and a touch of Light Red).

STAGE FOUR I painted in the background and cut it into the periphery of the image. Then I painted the clothing up and into the neck area, adding reflections into the overall shadow on his face.

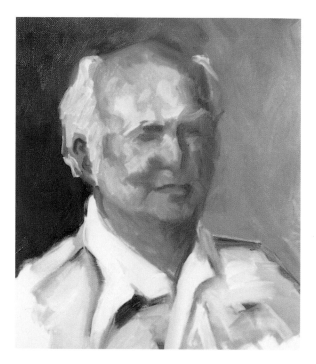

STAGE FIVE I finished the painting by adding darker accents to the shadowed area and restated the highlights with lighter tones, extending the lighter side of the face into the background, sharply in some places, fused in others. This is the all-important "found-and-lost line." After lightening the hair and adding the glasses, the portrait sketch, painted on a 20" x 24" canvas, was complete.

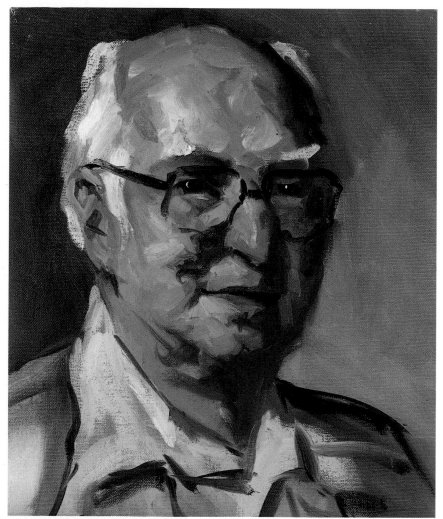

Final Comment: You may wonder why the tones of each shape were overlapped into the area of an adjacent feature because it looks as though the drawing is being ruined in the process. Actually, it is, inasmuch as you are making features appear by fitting together paint; you are not filling in a drawing. The fusion of tones in the right shapes models the face. This overlapping makes shaping with contrasting tones more accurate than putting them next to each other and blending them together. The finished painting shows the features are formed by visible strokes; they are not blended. This is the true look of *alla prima*.

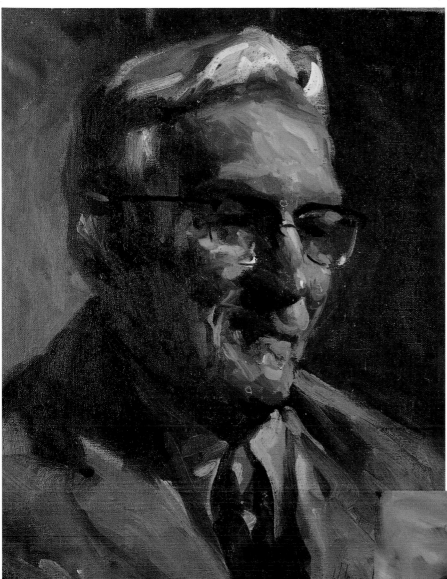

Demonstration Sketch

Demonstration Sketch,
16" x 20", oil on canvas.
I painted this at a demon-
stration somewhere in the
midwest during a tour of
the area. The procedure
I used for this *alla prima*
portrait was the very same
that I have described in this
chapter. This, too, is a prime
example of direct painting.

Portrait of Jennie, *14" x 18",
oil on canvas.* The model is
Jennifer Jolly, Herb's son's
step daughter. I painted her
on one of her rare visits to
Rockport. As you can see,
her face was perfect for an
alla prima interpretation.

Jennifer Jolly

Chapter 15

A Portrait's Progress, Step-by-Step

This series of painting steps is the actual progression of my portrait of Herb, this book's editor. I've accompanied each stage with a running commentary that constitutes my thinking process and my reaction to the portrait's progress. This is more effective than watching a portrait painting demonstration simply because the complete progression of the portrait is always handy for re-examination. When you watch an actual painting in progress, each step, as you know, is covered up by each successive one, thus obscuring the overall makeup of the painting procedure. This record of how I paint a portrait, therefore, will give you a chance to look back and see that the final result is completely dependent upon the quality of each step. So here goes:

STAGE ONE Herb posed in the lighting that I thought would describe his features well. I really wished that he would have sat up and leaned forward a little. We did work with a version of this pose, but he always seemed to fall back into the pose that is pictured. Herb's comfort with his pose, I felt, would contribute more to the success of the portrait than forcing him into a pose that only seemed natural to me. This stage looks very simple and may seem awfully elementary to comment on but it's extremely important. It's the first contribution to the look of the portrait. It records two decisions: What size the head will be and where the head will be placed from top to bottom and from side to side. These simple strokes can capture the very essence of the pose. If these strokes don't look right to me, I wipe them off and start over. Remember — the simpler the start the better.

Here are the marks that indicate the proportion of the features. I thought about the ears in relation to the nose, the forehead in relation to the hair, the size of the nose in relation to the space from the nose to the chin. Lining the corners of the mouth with the eyes is my way to deal with perspective: My view of the angle of Herb's face. All of my considerations tell me more about his face and guide me to construct a form that will make sense to a viewer. It's true that painting is a means of expressing one's self, but the painting process is more a thinking process than an expressing process. The look of my paintings reveals how I think and how I feel. My paintings expose more about me than even taking my clothes off would do. If I respect the structure of the face, I will record that respect and how I feel will be recorded also without my even knowing it. I'm convinced that painting is a mental exercise. The emotional experience is always there. It can't produce the picture; it only flavors it unconsciously. Now to describe the practicality of this stage: I never hesitate to make lots of lines and marks. Each one is a visual remark about

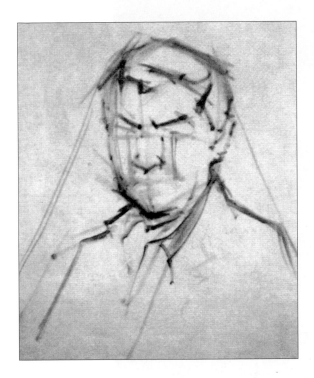

Herb's face. I make these marks with black that's been thinned with turpentine. I know of many students, who, at this point, will add white to lighten the black, thinking that a light mistake isn't as bad as a dark one. They find, however, that the white will lighten the black but will also make the mixture thicker, more a detriment to progress than thin, dark applications are. (If you find that black paint at this stage frightens you, use Raw Sienna instead.)

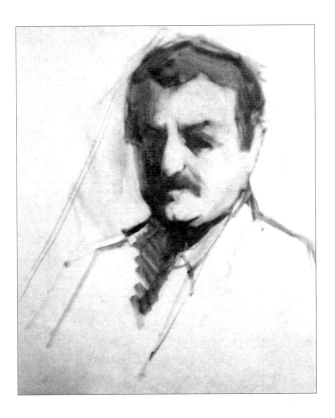

Now, a gray (a thin mixture of black and white) records the overall shape of the shadow in contrast to the shape of the body tone. I used a brush with the gray mixture and another brush that was wetted with turpentine to move and model these contrasts. This stage is intriguing. It's the same as sculpting with tone instead of clay: the sculptor adds clay for projecting planes and digs clay away from receding planes. What makes painting different from sculpting is that, in painting, the entire form has to be visualized from only one view. A sculpture, on the other hand, can be viewed in the round.

4.

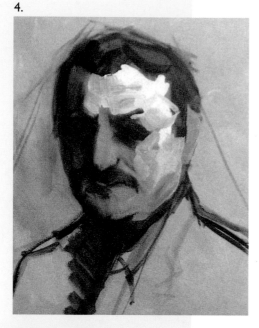

6.

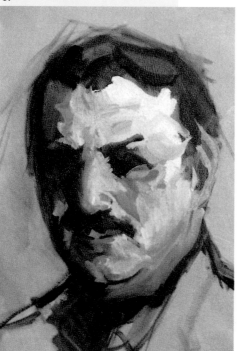

FOUR/FIVE

I moved a gob of white to a mixing area and added color into it to lay in the flesh colors in the part of the face that I call the body tone. At this stage, I hardly expect the paint to look like skin. I just invest the flesh colors with hopes that they will fit together and react to each other. I remember when I studied with M.A. Rasko and watched him whack in these flesh colors. I said to myself, "How are all those blotches ever going to look like smooth skin?" I soon found out as my teacher pulled them all together. Maybe you can understand it better if I were to compare this stage to a bowl of cake batter, which is a far cry from a finished cake. Teaching will never take the place of experience. So without blending, without anxiety, but with care, I patiently painted in the colors of the body tone.

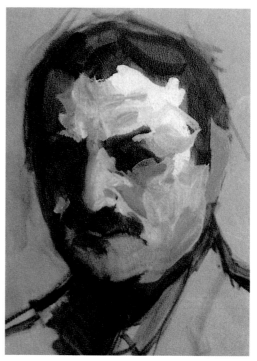

5.

STAGE SIX Now the entire flesh area has been filled in and the nose has been formed by the shaping of the shadow against the light flesh colors on the nose. I find that refining the shape of the nose is a good starting point because of its central location on the face. All the other features can easily be compared to the nose. This starting point does not contradict the progression of working from the top down, as described in the previous chapter. That is a bold approach that contributes to a loose look, typical of *alla prima*. A more conservative approach, such as the one described here — even though it is also an *alla prima* technique — makes the painting look more finished and the likeness more studied. It stands to reason that if more care and attention are given to an approach, a more formal looking painting will result. I use the progression of working from the top down for further definition and correction when doing a portrait such as this one of Herb.

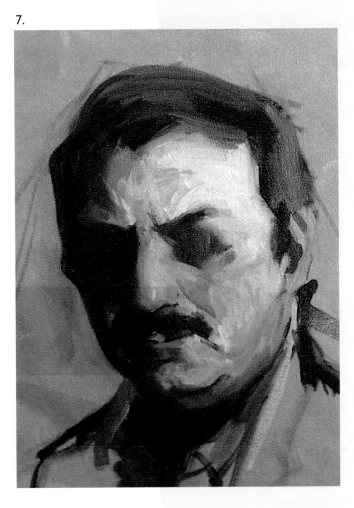

7.

STAGE SEVEN

I completed the shape of the shadows as they met the rest of the features. Compare the size and shape of the overall body tone in Stage 6 to the shape and size that it is in this stage. Notice that the body tone is now smaller. I find that modeling the body tone and body shadow together is far easier to do by first painting the body tone (or flesh mixtures) into the shape of the shadow, making it possible for me to subsequently use the dark shadow tone to cut it down, shape it correctly and, in fact, blend it by the cutting-down process. Notice, too, that the body shadow is still just one tone. My main involvement with shadows is their edges: Where they meet the body tone. The body tone, as it meets the hairline, was also shaped by cutting it down with the hair tone, and the neck was shaped by cutting it down with the collar. This modeling or shaping of the dark and light tonal pattern on the face is time consuming, frustrating, hard work and very tiring for the model — and for me. Needless to say, the end of the first sitting was welcomed.

STAGES EIGHT-TEN

I filled in the background before Herb began his second sitting. The tones of the hair were moved out into the background to show the shape of the head. The ascot and collar have been shaped up to the chin and up over the background; the clothing was painted down into a dark tone at the bare part of the canvas.

8.

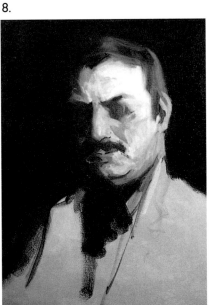

9.

10.

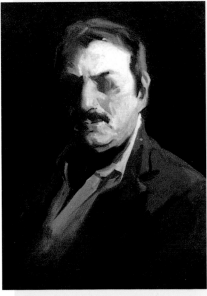

STAGE

ELEVEN

Now the entire shadow pattern is seen as warmed with dark flesh colors. I did this by adding to the existing shadows a mixture of Burnt Umber and Light Red. I always make this quite thin (with painting medium). This thin application creates a lovely luminous quality. For example: Alizarin Crimson applied thinly on a dark tone becomes a dark Alizarin Crimson; Alizarin Crimson applied thinly on a light tone becomes a light-toned Alizarin Crimson. This is a very simple description of glazing. Back to the portrait, I added the darker tones in the shadows with mixtures of dark, somewhat cool colors, such as Burnt Umber with a touch of blue. These darks add eyes to the eye sockets and define the nose and mouth. I darkened the mustache and worked its shape more correctly against the skin. At this point you can barely see the beginning of the glasses where the ear piece rests against the temple. I did lots of little corrections on the edge of the shadow, mainly by adding some slightly darker and more colorful flesh mixture on the edge just before the turning edge. It's important to see that the finishing stages do not deviate that much from the beginning stages. Many students think that the finishing stage can save a bad start. Not true. Knowing how to finish a portrait is realizing exactly what the word finishing means: To complete what was started.

11.

12.

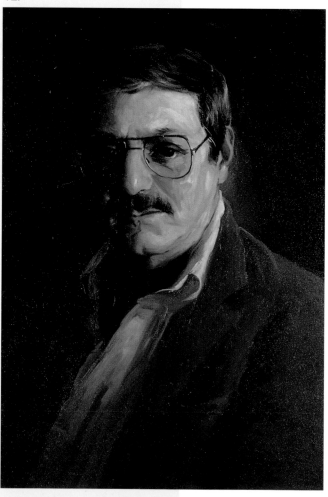

STAGE

TWELVE

The finished portrait. ***Herb Rogoff,*** *24" x 30", oil on canvas.* It is interesting to note that before I started this portrait of Herb, he had had his eyeglasses changed from his almost trade-marked black horn-rims to the wire-rimmed frames in this portrait. I hated his new frames and, as it turned out he did too; he ended up wearing them for a very short period of time.

Chapter 16

The Expression In a Likeness

❧❧❧

I t is possible to get a likeness but not an expression. Conversely, and just as futile, it's possible to get an expression but no likeness. A likeness, you see, is mostly a matter of structure and correct and accurate proportions; an expression lies in how you interpret the eyes and mouth. Of the face's features, the eyes and mouth are the most difficult to paint. Surrounding these features are movable parts, and it is the way that you treat these surrounding areas that will greatly influence and determine the model's expression.

The tones that record the expression around the eyes and mouth are subtle ones; they are not tones of complete light and complete shadow. They are in the general light flesh area near the shadow shapes. I deal with this problem tone by first massing in the entire area with a flesh color slightly darkened with a little bit of Burnt Umber and Thalo Yellow Green. Let's direct our attention to Karl-Heinz Michael's eyes in Figure 1 on page 70.

Jay Rogoff, 12" x 16", oil on canvas, painted in 1986. *In this portrait I painted of Herb's son, I got a good likeness and, what's more, captured an expression that was so distinctive to Jay's character: direct, intense and intelligent.*

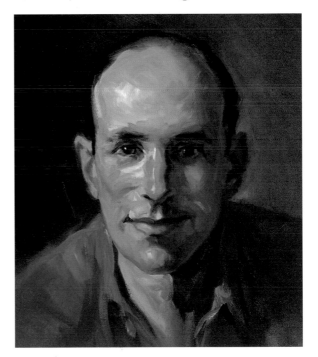

Figure 1. We see how this darkened flesh tone has been painted into the eye socket area and extended into the light areas around his eyes.

Figure 2. Shows how the body flesh tone has been painted into this tone to indicate the shapes of his upper lids, his lower lids, the whites of his eyes and, if Karl will pardon my saying so, the first bag under his eyes.

Figure 3. After moving the body tone of the cheeks up to the bottom of the "first bag," which is really the bottom of the eye socket, I began to treat the movable part surrounding his mouth in the same manner by putting in the darkened flesh tone to begin painting the subtle nuances of the expression. Compare this step with the previous one to see how broadly I extended it into the shadow pattern and on the body tone area.

Figure 4. I then modeled the cheeks down into this dark flesh color with lighter flesh tones. The upper part of the smile greatly affects the cheeks. Notice how lighter tones, painted into that darkened flesh on the right cheek, show his matured dimple.

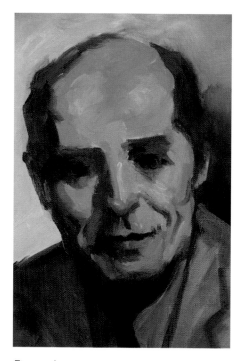

Figure 1.

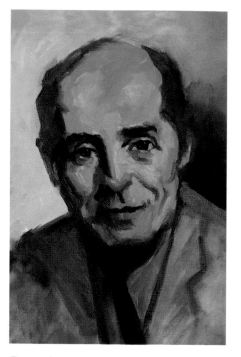

Figure 2.

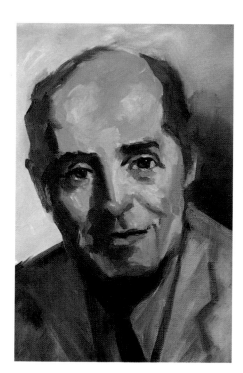

Figure 3.

Figure 4.

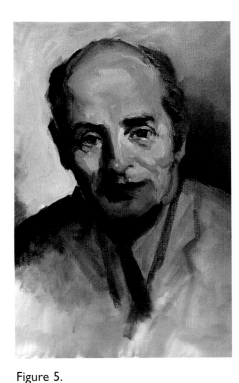

Figure 5.

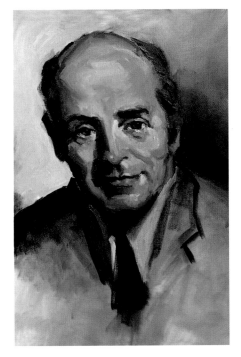

Figure 6.

Figures 5 & 6. Again, darker flesh tone was massed in over the jaw and chin area so the lightening process could once again define the characteristics of Karl's mouth and chin. This is shown in Figure 6.

Figure 7. Shows how even slightly lighter additions to the light planes of his face further zeroed in on his expression. Notice them on the upper lids, lower lids and especially where I lifted the smile a bit by that important shape — the lower corner of the mouth.

You can see by this step-by-step demonstration that getting an expression in the eyes and mouth is more a matter of working around the features than on them. This is called "modeling" the face, and students often try to do it by blending darker tones into light tones. The reverse is much easier, and more effective.

The finished painting. **Karl-Heinz Michael,** 16" x 20", oil on canvas. *Karl seems to be looking right at you. We tend to relate more personally to a portrait such as this one. If your model finds it difficult to look you "straight in the eye," then paint eyes that look somewhere else.*

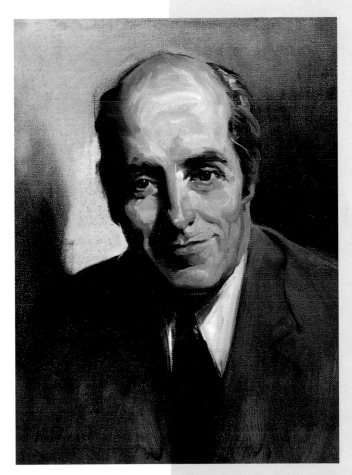

Figure 7.

Chapter 17

Planning Your Portrait's Development

❦

When your sitter is on the model stand and a blank canvas is on your easel, you are faced with two extremes: a beginning and an end. It's difficult to find a beginning when the finished product — your model — is your constant, visible point of reference. Often, a student tries to make his paint reach out and paint the finished look instead of finding a beginning. It's the same as preparing a meal: we all accept as fact that a lot of preparation is needed to put a meal on a table. Why, then, do so many painting students think of oil paint as being omnipotent? Why do they think that one can pick oil paint off a palette with a brush, apply it to a canvas and, in one fell swoop, make a finished look?

The best way to cope with the limitations of oil painting is to devise a plan that will build an image in a progression of easy applications. I went about painting Phil Carter in this way, one that I thought to be the most practical:

1. *On a medium-toned canvas, I placed and indicated the proportions of head, face and body.*

2. *Then I painted the lighted portion of his face, shaping it in with the shadows on his face.*

3. *Next, I painted the light on the hat, and indicated a placement for the eyes.*

4. *The darks and lights came next with features being more clearly put into place.*

5. *The lighter tone of the background around the image followed to correct and improve the periphery.*

6. *Now I painted the darker darks, emphasizing the eyes that fell into shadow from the peak of his hat.*

7. *Finally came the lighter lights on Phil's face and the cap.*

When you work out a plan of attack, decide what is structural and what is decorative. Deal carefully with all the structural elements first and then trifle with the decorative elements. Your applications will make people view the important elements with interest and they will just glance at what you have treated lightly.

Figure 1.

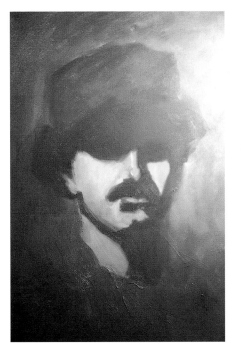

Figure 2.

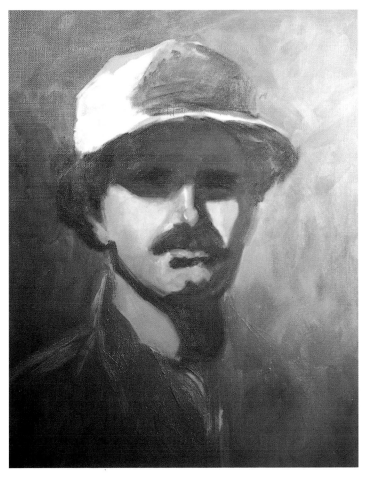

Figure 3.

Figure 1. Limit your indication of the placement to as few lines as possible. Why? Simply because it takes but a few lines to see whether the placement looks right to you. If it doesn't meet with your approval, these few lines can be easily wiped away with a turpentine-soaked rag.

Figure 2. The overall shape of the light pattern on the face should be painted in one tone. The flesh colors of the body tone may vary in hue (pinker, yellower, redder, etc.) And in intensity (brighter colors or duller colors), but the tone should be the same. By squinting at your work, you will be able to see the tone of your color better than if you view your painting with both eyes wide open.

Figure 3. Force yourself to establish uncomplicated basic shapes for a strong feeling of solidity. Remember, you can always work into these forms with variations and details. By painting these variations and details in the beginning stages you'll end up with a picture that looks flat instead of dimensional.

Figure 4. It's at this stage that two basic shapes — light and dark — are fused together. This is the time for working on the turning edge. Many think that this is a blending stage. It's really a stage of sculpting with the light and dark to form features.

Figure 5. The interplay of the background and subject is a fascinating stage of the picture's development. Try to concentrate on the appearance of the subject's periphery and work on the edges that record it. Most edges that constitute the subject's silhouette should be painted by overlapping strokes on a background that has been painted slightly into the actual shape.

Figure 6. Now that a background has been painted and the edges have been repaired, more detail was painted on the shirt, and an indication of the design on the hat was recorded.

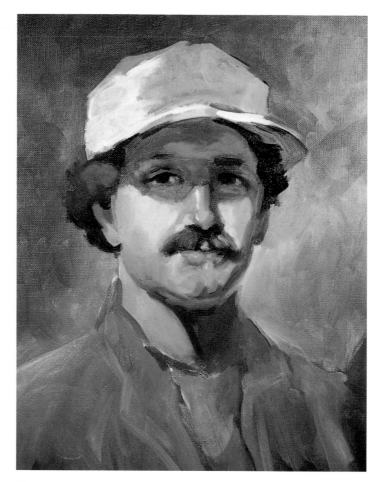

Figure 4.

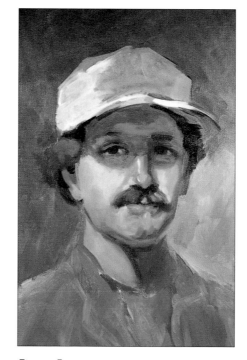

Figure 5.

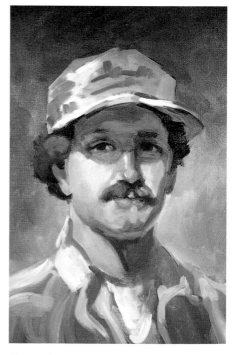

Figure 6.

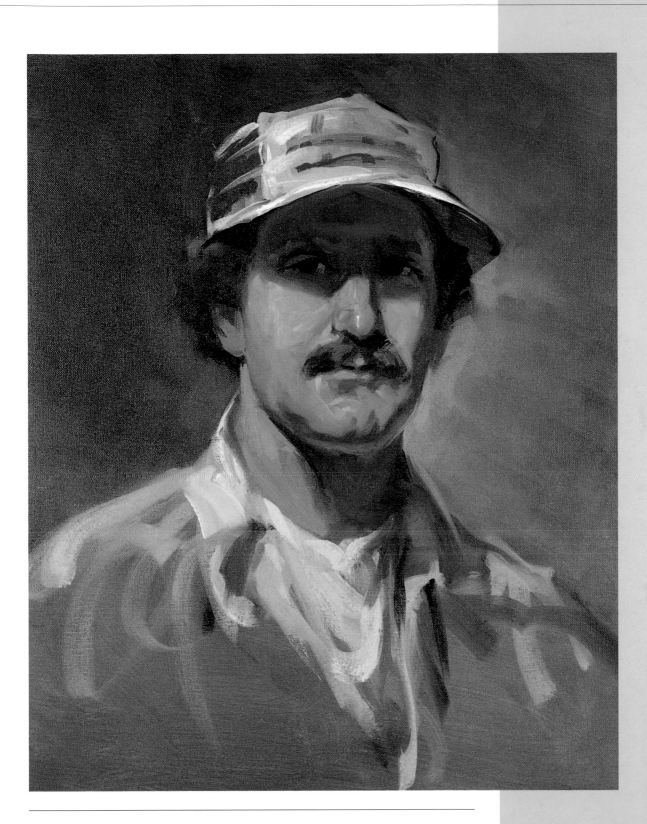

***Figure 7.* Phil Carter,** 20" x 24", oil on canvas. *Into the dark pattern, the darkest darks were added and the picture's development was brought to an end.*

A Simple Analysis of a Portrait Sketch

Although it may look complicated, a portrait's basic structure is made up of only three elements. They are:

- A shape of a light pattern on the face, called flesh color or body tone.
- A shape of a dark pattern on the face, called body shadow.
- The subject's silhouette, which records the image, his hair style and clothing.

Think of the model to be these three simple elements. Seeing him this way gives you a chance to concentrate on the difficulties of each of them instead of being overwhelmed by the entire project. What are these difficulties? Let's look at each element:

The Body Tone:

- Must be well shaped by the shadow.
- Should be well covered with paint.
- Must be made of clean, light color with no darks in it.

The Body Shadow:

- Must be well shaped by the body tone.
- Should be comparatively grayed color.
- Should have no tone in it that's as light as the body tone.

The Silhouette:

- The outline, or periphery, should be the correct shape and should be sharp and fuzzy to show projecting and receding planes.

While my husband's son, Jay, was visiting one weekend, I was tempted to do a portrait sketch of him. I prepared my materials and toned a canvas with gray (it's still visible at the bottom of the picture). A light, medium-toned gray is far easier to work on when doing a portrait sketch than the stark white of most commercial, pre-stretched canvases. In fact, a white canvas is the most difficult tone to relate to when doing a portrait. After all, there are hardly any areas of the skin that are as light as the white of your canvas. A neutral tone — lighter than the shadow tone but darker than the highlight on the skin — is a much more sympathetic tone value to work on.

I arranged my palette in my usual line-up of colors, half filled a pound coffee can with turpentine, and picked out five brushes (three red sable Brights, sizes 8, 12 and 16, and two white bristle flats, sizes 8 and 12). Armed with workable materials and a simple analysis of the project, I did this painting of Jay in two hours. I'd like you to refer to his portrait as you read

about how I painted him. You will recognize that I basically worked on the three elements of a portrait's structure: the body tone, the body shadow and the silhouette.

1. I first wetted a cloth with turpentine and wiped the surface of the canvas a bit. By doing this, any unwanted marks of paint could be easily removed from the damp canvas with the same cloth. Paint that's applied to a dry canvas is much harder to wipe off. Feeling secure about being able to erase with my rag, I placed the size of the head with two bold marks. Made with black paint, the marks indicated on the canvas the top of his head and the bottom of his beard. Jay is not tall or what I would call extroverted, so I thought that a lower placement might suggest his countenance more accurately.

2. The two marks became an overall size for me to then determine where his eyes, his nose, his mouth and his hairline were. The eye line, you'll notice, is one half of the entire head size, and the forehead is one-half of the size between his eyes and the top of his head. In fact, check the proportions of Jay's face with those in my early self-portrait that appears in Chapter 2 to see how these proportions in humans seldom deviate.

3. With these structural indications as guide-lines, I was able to mass in the shape of the shadow on the right with a gray, made of black, white and a touch of Burnt Umber, and suggest the darkness of the hair, beard and cast shadow from his head on his clothing using a darker version of that same gray. This is seen in Figure 1.

4. Automatically, I was led to painting the body tone wherever the flesh color showed. I started to paint the flesh area by establishing the tone and color of the highlight on the forehead (white, Cadmium Yellow Light and Alizarin Crimson). I often do this because the highlight tone will then act as a tonal key for the rest of the flesh mixtures. That lightest tone of flesh tells me that all my other flesh mixtures must be darker in tone. In the final flesh development, this highlight may very likely be redone, but at this stage, it is a helpful starting point for the many mixtures of flesh that are needed for the various planes of the face. See Chapter 8 for flesh mixtures.

Figure 1.

Figure 2. The finished sketch. **Jay Rogoff,** *20" x 24",* *oil on canvas, painted in 1976.* Compare the finished portrait sketch with the diagram to see how it is basically the same in tonal arrangement.

5. As this flesh color neared the receding plane of each feature, I used a cool gray made of Payne's Gray mixed into the darkest flesh color of the body tone.

6. I added some warmer color (Light Red and Raw Sienna with black and white) into the shadow on the right, for the appearance of reflected light. These two shapes — the body tone and the body shadow — were then delineated by the darker tone of the hair and the beard.

7. I moved the outer shape of Jay's hair, clothing and beard out into the wet, gray background that I had quickly washed in during the model's break. This outer periphery (often called an outline) is such an important contribution to the entire pictorial effect that I took great care to form it. Notice that it has variation in its delineation — some sharp edges and some fused edges. I did this by applying the paint in the interior of the shape and moving it out toward the outer edge. An outline is really where a plane disappears from sight because it falls away from your point of view. See how the sharp outline in Figure 1 does not look as dimensional as the outline in the finished portrait sketch *(Figure 2)*.

8. The darkest darks of the eyes, nose, mouth and the eyeglasses were final touches. These darker accents are usually warm (Burnt Umber and Alizarin Crimson into dark gray).

9. I put in, very quickly, the turtleneck shirt and sweater. The way you indicate the clothing should be simple and spontaneous. As soon as you labor on the clothes, the appearance of the way the paint interprets the face will look far too sketchy. To paint the design of the clothing with bold strokes, you must have your brush loaded with paint to make sure that one stroke is enough to cover and stops you from having to go back and overwork it.

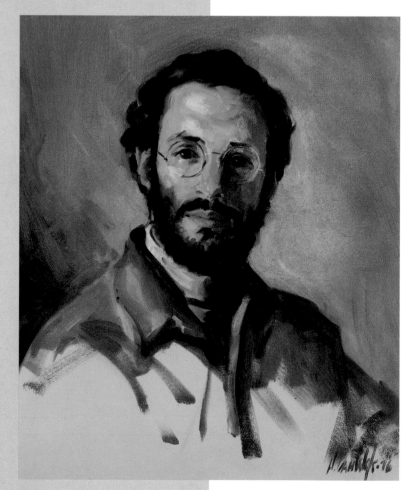

Figure 2.

Painting Loosely

❧❧❧

T he comment, "It was so loosely painted," describes the look of freedom, spontaneity and casual application. A "loose" technique is greatly admired because it seems more "arty" and expressionistic. Whenever I am asked how I got such a loose effect in a painting, I immediately say, "I was in a hurry." Sassy answer? Not at all. It's truly honest. The pressure of time is a valid contribution to the painting process that produces this loose look.

No matter how a painting looks, no matter what the subject is, every painting is made up of six components. Let's analyze them:

1. **Composition:** *the design.*
2. **Drawing:** *the structure, proportion and perspective.*
3. **Tone:** *the contrasts.*
4. **Color:** *the hue and intensity of the tones.*
5. **Rhythm of application:** *the brushwork.*
6. **Found-and-lost-line:** *the sharp or fuzzy joining of contrasts.*

And all of these six ingredients are influenced by the painter's motivation and inspiration. How much time an artist has to paint a picture will influence its appearance. Of course, the painter has to decide and

plan how much time he needs for each inspiration. If he sets aside a lot of time it is because he feels that he needs a lot of time to get the effect that he wants. If he is inspired to paint someone and knows that he has little time, he has to work in a way that can be fitted into that shorter time period. It's easy to see that all of the portraits that I have painted while demonstrating were done under the pressure of time. I have taken as little as twenty-six minutes for my thirty-minute television shows to as long as two hours at my painting workshops. I would say that the average length of the portrait segment of my demonstrations in front of art groups is one hour. The demonstrations I do socially, either during cocktail hour or dessert, I try to keep to thirty minutes or less. My audiences in these instances are my dinner guests, most of whom do not paint, and while my main motive here is entertainment, the principles I use, nonetheless, are quite valid. The results, I might add, have been some of the best sketches I've ever done. So, I hope you can now better understand my answer about painting the "loose look." Putting this into practice, here is the procedure that I use whenever I feel like just capturing on canvas a person at the spur of the moment:

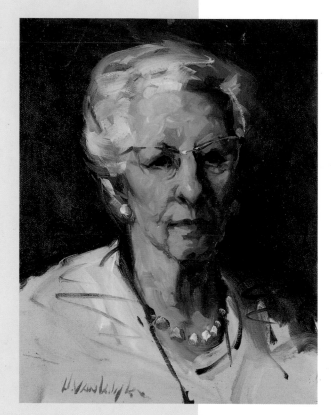

Jessie Cox. A feisty, dominating old woman. I think I captured those qualities.

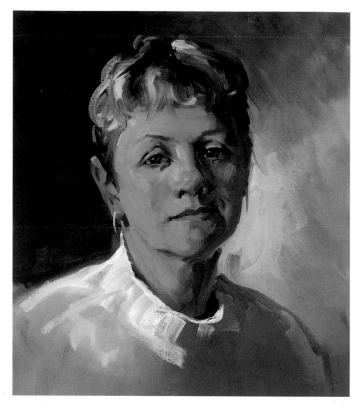

Judy Stap. Her husband, my cousin, had been anxious for years for me to paint this portrait.

1. Naturally, my palette of colors, brushes, rags and medium are arranged and ready.

2. I wash the canvas with a medium tone of warm gray made of black, white and Burnt Umber.

3. With a rag wetted with turpentine, I wash away the gray to place the head in the size that I want it to be.

4. With a medium warm gray (black, white, Alizarin Crimson, Raw Sienna and Light Red) I boldly paint the shadow pattern that falls on the features from one strong light. This shadow from the top of the head, on the features and down to the neck, should be one continuously connected tone, giving the head an immediate feeling of solidity.

5. I then paint in the flesh-colored area with a colored tone that's darker than it actually is: flesh color mixed into a very pale gray.

6. I paint in the background to enable me to paint in the hair, like the flesh color, also darker than it really is.

7. Now the fun starts by adding lighter light flesh

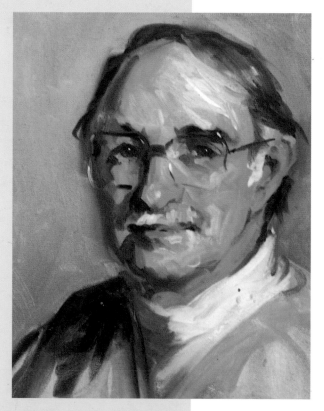

John Allen Oakes Sr. He endorsed me from my very first stroke on canvas.

tones to the flesh-colored area and darker darks to the shadowed area.

8. I finish by adding light tones of hair color to the hair and a few strokes to suggest the clothing, jewelry and eyeglasses. The light and dark accents are painted on top of the two basic light and dark patterns with a well-loaded brush so each stroke doesn't have to be repainted.

Carefully examine the portrait of Jessie Cox and notice how descriptive the last strokes of dark and light are. Then try to look underneath them and see how the basic light and dark patterns established the structure of the head and features.

Each one of the oil sketches in this chapter was done in less than an hour. Why? Because, as I just explained to you, that's all the time that I had. Here are some comments about the sketches pictured on these pages:

I painted Jessie after we had been out for dinner with her and her son, Bob, on the evening before they had to return to Detroit. At that time, Jessie was in her eighties; she was a marvel for her age but the hour was growing late, and she was quite exhausted. I used a strong spotlight to force the shadows and the contrasts. I knew I had to work fast since it was difficult for this woman to sit still with this strong, hot light focused on her face. Furthermore, the thought that I might not see Jessie again made me paint her that evening. As it turned out, that sitting with Jessie was the last time I saw her.

I chose to paint John Oakes at a demonstration in Connecticut, first, because his face interested me, and — second — he was the father of a student of mine, Terry Oakes Bourret, who has developed into a fine painter and teacher. John was a cooperative model, and I enjoyed how he looked at me with a twinkle in his eye. The large audience was enthusiastic about the demonstration, which pleased me the most because, after all, they were the true motivation for this portrait.

Judy Stap is my cousin John's wife (you've seen his portrait in a few of my books). They were visiting from Maryland and I painted Judy after a lovely lobster dinner. I painted her that night because John was anxious to have a companion piece for

Margaret. A portrait painted before the TV cameras. Talk about pressure!.

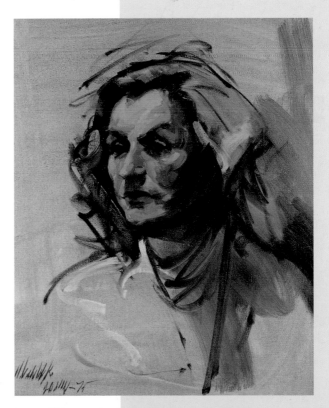

Henni Wegner. A dynamic portrait painted "under the influence."

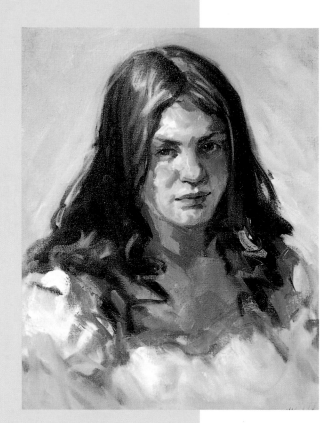

Wendy Leventer. A going-home gift for a summer guest.

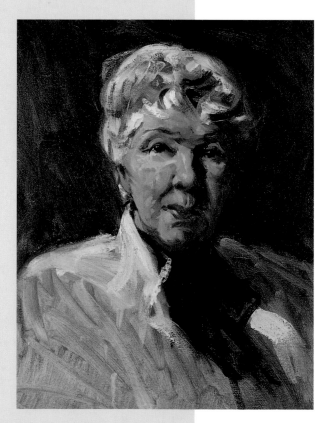

Ethel (Jean) Pate. A class act all the way.

his portrait, which I had done a few years earlier. I'm glad I did this sketch; she was a beautiful model.

I can only identify the model with her eyes in shadow as Margaret (and I hope I got that right). At the time I painted her she was an employee of WMHT, the PBS station that produces my show, "Welcome to My Studio." I needed a model, saw her in the corridor and asked her to pose. As the technicians in the studio were adjusting the lighting, I saw this effect in a fleet moment and stopped them right there. "That's it," I said, "I'll paint her in this light." With twenty-six minutes to do the program, including the few minutes I customarily use for my opening remarks, you can see that I was in a hurry. Shading her eyes the way I did made it easier for me for the obvious reason: I didn't have to paint them.

Henni was introduced to us by our Rockport friend, John Hurley. They came for dinner and during an extra-long cocktail hour I took the opportunity to paint this fascinating woman. Henni had been in Germany during the entire war in the employ of a high-ranking German army officer, who, along with her, had no use for the Nazis and their maniacal leader. The way I treated the sketch, as you can readily see, was in an extremely loose manner. Time was not a factor in this case. I'm afraid the number of martinis I had consumed had something to do with the appearance of the sketch. We won't tell anyone, will we?

Back in 1971, Herb's daughter, Leslie, came for a summer-long visit and brought with her a friend, Wendy Leventer. Before they left for New York and school, I asked Wendy to pose for me. This portrait sketch took me about forty-five minutes. Wendy's father, Lou, who was to drive the girls back, looked on. He told me afterwards that he felt the same during those forty-five minutes as he did the day Wendy was born.

Jean Pate was an uncommonly interesting woman. She spent a lifetime in theater, mostly on the Broadway stage. I met her when she retired to Rockport. She was a great friend to us and to

my mother, who would sit for hours in awe at the stories Jean told about the Barrymores and other acting icons. The 45 minutes that I spent painting her ended up to be a stimulating experience. It took place one summer evening after we had finished a casual dinner of Veal Marsala. I may forget a lot of things about the past, but I never forget the meals I served.

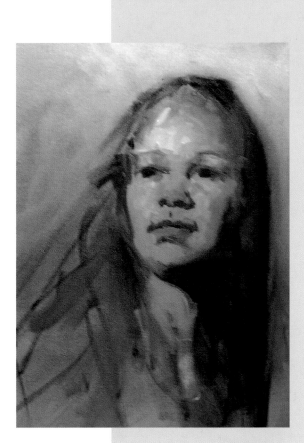

Shown here is an early step in the demonstration painting of Melissa McDonald. You can see that all of the elements are there, just as in my more finished portraits. The unfinished (or loose) look is a result of how much time the painter has, or chooses to have, for the finishing touches.

After the demonstration, Melissa posed for this picture along-side her portrait. I would have loved to have had more time to work on her hair and perhaps to give this pretty young woman a trace of a smile, just as she displays in the photo. But these are the hard facts that you will face: the pressure of time contributes mightily to your course of action.

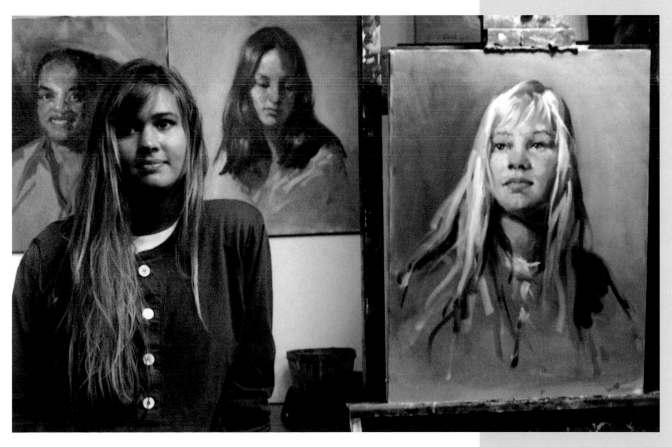

Chapter 20

Wet-onto-Wet Painting

✦✦✦✦

You may not recognize the title for this chapter because many art students know the term that's promiscuously used in books on painting as "wet-in-wet." In my opinion, the term wet-in-wet is misleading.

The better way to describe this technique, as I like to do, is as wet-onto-wet since this suggests that more paint is being applied onto a previously painted but still wet area. The thickness and slow-drying property of oil paint invites this dangerous type of application, no matter what we call it. A subtle addition can be embedded in the already painted area by exerting pressure on the brush. More dramatic tonal additions can be made, however, by piling on top of the existing paint more paint through use of a light touch of your brush.

The flesh side, where we see many nuances of color and tone, is where wet-onto-wet applications seem to be needed. The shadow side's colors and tones are usually so diffused and obscured that little work has to be done in the shadow other than getting its basic shape right.

Painting flesh with wet-onto-wet applications is a procedure that evolved through necessity. There are two factors about a body tone: first and foremost its overall shape; secondly, its texture. An initial layer of paint can describe the body tone's shape as it establishes the basic color of the skin. The wet-onto-wet applications can record the texture of the skin, the shine on the skin and the little variations of the color of the skin. These variations are easy to apply if they are lighter tones than the basic color. Light tones are thick because of the amount of white in them, and thick paint can be laid on top of paint that's relatively thinner.

Wet-onto-wet applications shouldn't be confused with, or thought of as, corrections. True, correcting is a constant part of painting. Working into wet paint to move it into better shapes can't be denied. But wet-onto-wet is a valid painting technique. Look at the illustration of Will Cabana. It shows how the portrait looked before the wet-onto-wet strokes were applied. Here are the color mixtures for the subsequent wet-onto-wet strokes for Will's portrait:

All the obvious brush strokes on his face are the final wet-onto-wet strokes of relatively cooler flesh colors, ones with more white and tending to be more pink by using more reds in the flesh mixtures: Alizarin Crimson, Cadmium Red Light or Venetian Red. These lighter accents were purposely saved for later wet-onto-wet applications. I said right from the beginning of painting Will: "I'll save these shapes for last." The body tone of the gray hair was massed in with a somewhat warm gray (black, white and Burnt Umber), and then it was further developed with

wet-onto-wet applications of a very light gray-blue (black, white and Thalo Blue).

A red sable brush is the most suitable one to use for wet-onto-wet applications. I've seen many students use a bristle brush because someone in their painting past told them that "bristle brushes will pile on color." Actually, the stiffer, more inflexible bristles of bristle brushes make them dig in and move the all-important basic colors of the flesh. A red sable brush, on the other hand, can lay additions of color onto this precious mass tone, making a further comment about the appearance and texture of the skin. Save your new red sable brushes for this stage of the painting. Sizes 8 to 12 are ideal, and they should be the chisel-shaped type — a Bright or a filbert. Don't use small, round red sable brushes for this maneuver, or for anything else in painting, for that matter. A little brush in your hand makes you look for little things, and makes you do them in little ways. Little round brushes only seem to be efficient at refining very small, dark shapes that are only found in body shadows, such as nostrils, corners of the mouth and the darker darks of the lid area of the eyes. Small red sable Brights, you'll find, are much better for this job.

I realize that more than a few of you will groan at the prices (ever-growing) of red sable brushes. You may find some relief in the coming-of-age of synthetic brushes, the ones that simulate red sable. These brushes perform quite creditably for wet-onto-wet painting where the laying-on of color over applications of wet color is critical. The prices, you will happily discover, are ones within your budget. Regardless of the brush you will use, experiment a lot with wet-onto-wet; you're going to need lots of practice to make this daring technique work.

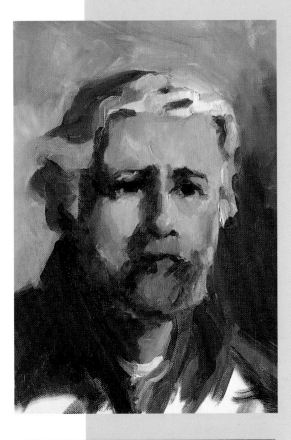

The portrait of Will at a stage before lighter strokes of color were added to the body tone. When you compare it to the finished painting you will notice how the additions don't change the overall shape of the body tone.

The finished portrait sketch of Will. Study it to find all the final tones that were added into the body tone and body shadow. Will's face and personality were very suitable to a wet-onto-wet approach. I could never see Will in terms of smooth paint. Let your models impress you and let that impression motivate your painting. Don't force it though; just let it happen.

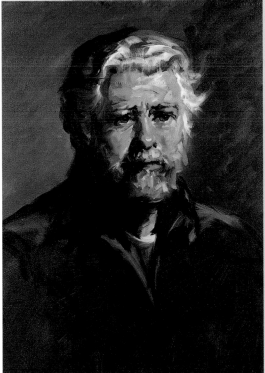

Working with Photography

❧❧❧

Photography has been around since the mid-1800s and has influenced portrait painting greatly. Painters whom we consider to be great, such as John Singer Sargent, James McNeill Whistler, and others in that exalted group, were reported to make use of photography in their pursuit of credibility in their work. To deny how photography can help you with your painting would be like denying that there's such a thing as electricity and, then, as a result, painting only by candlelight.

Once you decide to use photography, remember that the only role it should play is to facilitate the painting process. Don't just slavishly copy a photograph. Use it as a reference for a painting just as you would use a live model. When you work from a model, you're interpreting an individual with paint because you're painting a three-dimensional object on a two-dimensional surface. When you work from a photograph, you tend to only copy from the two-dimensional photograph onto your two-dimensional canvas. Only after many hours of study from a live model will you have the experience to use photography effectively. You will then be able to see a photograph of a person more as a live model and be able to interpret the tones of the photograph as you would the tones of a model's face.

There are times when you must use a commercial photograph, such as the obvious one of painting a portrait posthumously. When using such a photograph, you should credit the photographer, if you know his name. This information can appear along with your signature on the front of the painting and also on the back of the canvas, painted lightly with a bristle brush that's been slightly wetted with a color. If you don't know the photographer's name, however, merely indicate that you did copy from a photograph with the words "from photo" written under your signature and, again, on the rear of the canvas. When you work from photographs that you have taken yourself, you need not cite any information about using photography as your source of reference. Your photographs are merely your means to your end.

Taking photographs of your model to help you paint the clothing, hands, hair, etc., surely cuts down on sittings and gives you more freedom to work at your own pace instead of being bound by your model's availability and convenience. Your photographs can also help you determine the "right pose." Before the inception of photography, artists had to make many thumbnail sketches to see how the pose would work out. I don't always use photography but whenever I have to paint children, my camera is a must. Here is my procedure on how I use photographs to paint children, especially young ones: *(continued on page 88)*

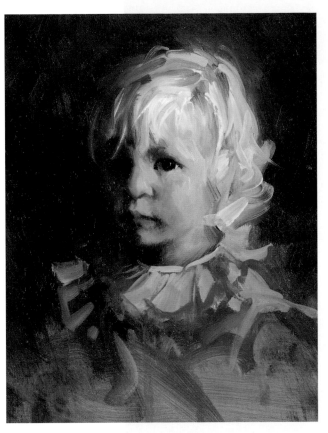

Chelsea Atwood

Denise Attwood, a student of mine, is shown with her daughter, Chelsea. I used this picture as the inspiration for my portrait of Chelsea, which is also shown here. Please notice that the photo itself has no merits aesthetically as a work of photographic art. I am not a photographer. I used the color shot merely as a guide to then paint a portrait of a very young child whose attention span was of short duration if not non-existent.

Danny is the son of Tuesday Lady and friend, Eleanor Driscoll. He came to our house with his parents one Sunday afternoon, and I was dying to paint the little guy. I sat him on a high stool on my model stand prepared to photograph him. But Danny sat so well that I decided to paint him then and there from life. The result was one of the best sketches I'd ever done. Here's a rare case of painting a young child from life thus negating the use of a camera. By the way, today he is Dr. Daniel Driscoll, a surgeon on the staff of the world-famous Massachusetts General Hospital in Boston.

(Page 88) I'd see Rachel go by my studio window on her way, with her mother Nancy, to the school bus. She absolutely had me entranced. I knew I had to paint her, so one day, I ran out with my camera and took this photo. I eventually got around to painting the portrait; it's also shown here. You can see how I managed to inject some spontaneity into the portrait. It's important to do this in order to get rid of that "photographic look."

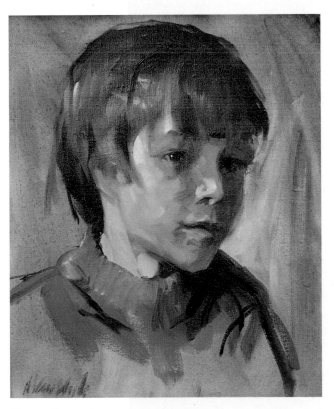

Danny Driscoll

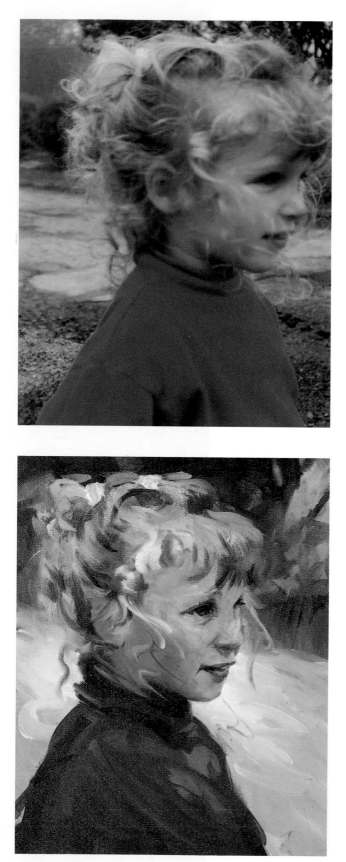

Rachel Higgins

1. I take many photos (an entire roll) in my studio.

2. After choosing, from among the many photos, the pose that I want, I sketch the composition and proportions on the canvas. A photograph for this step is vital since most children can't sit still long enough for the accuracy that this stage requires.

3. Just before the first actual painting sitting, I paint the shape of the body tone, body shadow, the background and suggest the body.

4. Then, when the child poses, I adjust this work according to how the model looks.

5. I then refer to the photograph again to refine the work I did so quickly during the child's sitting.

6. Finally, the child poses again for finishing touches.

Another way that I use photography is when, at the first sitting, I can detect that the model won't be a good one. Once I notice this, I stop painting and photograph the model instead. Don't ever put your painting's success in jeopardy by working under the duress that a poor model can cause. A good portrait is very dependent upon a good model.

One source of light that causes interesting contrast on the model's face is essential to painting, making flash photography totally valueless. This lighting can be a spotlight or from a window. A camera's flash will illuminate your sitter directly, thus washing out any lighting that is present in the room. Never, never, therefore, photograph your model with flash. Buy, instead, the fastest films that you can get. Ask your photo supply dealer about these films and how to use them while using one source of light.

When using your camera, you must always keep in mind the fact that a photograph is a photograph and a painting is a painting. Neither should try to be the other. Both are means of pictorial expression and both tempt and tax our taste and artistic point of view. You have to decide whether you are fascinated with the look of a painting or the look of a photograph. It's important to remember that you are using your photographs as source material not for reproduction or exhibition. The value of photography lies in the help it gives you with your paintings; the quality of the photographs is incidental.

While rummaging through some old photographs of family and friends, I found this one of my first cousin Helen Canova (nee Baker). Someone had cut this snapshot, obviously, to fit into a scrapbook which was in my mother's possession. I saw in the old picture the possibility of a painting. It is reproduced here along with the progressive steps I used to paint it. Mind you, the painting is far from being what one would call an "important piece," but to me it puts color to a memorable moment on a park bench many decades ago.

Step 1. This simple sketch indicates the position the young lady (my cousin Helen) is taking as she reclines on the bench. It shows the placement of her figure in the painting.

Step 2. I painted the figure with broad strokes to indicate the basic tone values as seen in her face as well as her dress and hat. The background is cut in around her, and an indication of the bench is added as well.

Step 3. The face, hair and hat are brought more into focus and the background and bench are more carefully painted.

Step 4. Lighter lights and darker darks are added to the dress and the flesh tones of the arms and hand, and careful attention is paid to capture the casual and charming way the model is seated on the bench.

Painting Eyes

One summer, in one of my classes in Rockport, I had a student from Virginia who could only study for one week. His limited painting time imposed some pressure on Sid, the student. When I reached his easel to see how he was doing, I saw that he had painted only one eye, and I pointed this out to him. "I know," Sid said, "but since the other eye is just like it, I'm going to do that one at home."

I find that this is an appropriate story to tell you before starting to instruct you on how to paint eyes. First and foremost — you have to make a matching pair. This can't be done Sid's way. To make them match is to develop them equally.

My portrait of Cathy Gale, a one-time student, is an ideal one to use as an example of how to paint eyes. Cathy, as you can see, has wide open, endorsing eyes, the kind that makes everyone in her presence feel at ease.

What follows is a step-by-step progression of how to paint eyes:

- **Step 1.** Into the mass tone of the entire eye socket area, add a darker tone to indicate the shadow from the upper lids on the eyeballs. With the same tone, paint in the irises.

- **Step 2.** Add any light shapes to the basic shadowed eye socket areas. These lights usually appear on the upper lids, the lower lids and the lower part of the eyeballs themselves.

- **Step 3.** Check to see if there are any more darker accents.

- **Step 4.** Finally, finish the irises of the eyes. They are glasslike and usually have rather light, sharp highlights. The color of the eyes is visible in a lighter tone directly across from the light. Add these highlights and the reflections of them after you have darkened the pupils and have added the visible color of the irises to the basic gray mass

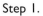

PUPILS DARKER
LIGHT

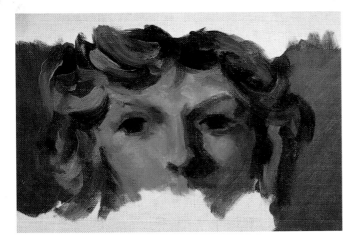

Step 1.

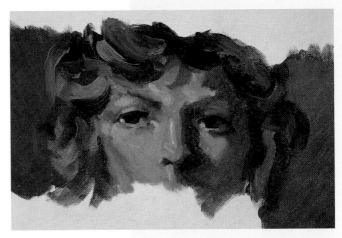

Step 2.

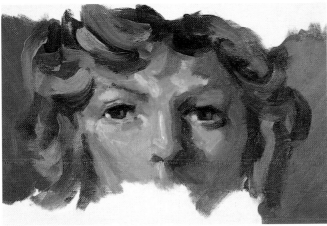

Step 3.

Step 4. The finished portrait. **Cathy Gale**, 20" x 24", oil on canvas.

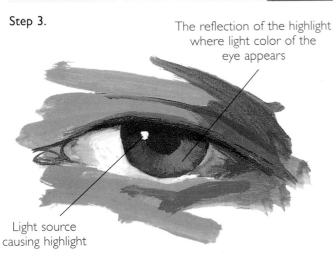

The reflection of the highlight where light color of the eye appears

Light source causing highlight

Caution "Don't shoot until you see the whites of their eyes" was voiced at Bunker Hill during the Revolutionary War. Although it may be a good rallying cry, it has no color validity, for if you look carefully at the tone of someone's eyes and compare it to the other tones of her face, you'll see that the whites aren't white at all. In fact, they're not even light. Here's a basic mixture for the whites of eyes: add white into the basic flesh mixture and then gray it with either Burnt Umber or Ivory Black.

Chapter 23

Painting Eyeglasses

Eyeglasses, and how they affect a likeness, need some careful consideration. Since they are always added after the eyes have been completed, you and your model can decide whether or not to include them. Once you've both resolved to include them, your painting ability will be put to the test again. The best way to meet this challenge is to add glasses when the eye area is dry to the light touch of a brush.

First, the look of the eyeglasses should fit in with the look of the painting. Too many students paint eyeglasses as though they are the portrait and the subject merely someone hiding behind them.

Second, you have to be careful, especially when you have to add glasses to a wet area, not to make mistakes. The corrections might mar the flesh color.

Before I go into a step-by-step demonstration, I want to tell you that you only have to paint the shape of the frames not the glass itself. Chances are you'll see highlights in the glass. Don't paint them! The frames only suggest the presence of eyeglasses; that's all you'll need for the illusion.

In this chapter, you will see a portrait of Herb that I didn't paint. It's by portrait painter, Lajos Markos, who painted Herb in 1967. Even

though he treated the eyeglasses a little more finished than I usually do, his procedure for doing them was exactly as I explain in the step-by-step progression.

But, first, a note about this artist. Despite his celebrity in his native Hungary, and the number of years he has been in this country, Lajos Markos is little known to American students and art collectors. Markos came to the United States in 1956 after the short-lived Hungarian uprising against the Soviet Union. He soon began to receive portrait commissions, a number of which were of prominent personages. Shortly after he painted his excellent rendition of Herb, he moved to Houston, Texas, where he spent the rest of his life painting Western scenes for the many fans of that genre in the Houston area and its environs.

I have chosen one of the many portraits that I painted of Herb to demonstrate how to add eyeglasses to a portrait. Incidentally, in my painting of Herb you can see an entirely different interpretation from the one by Markos. Viewed side by side, a majority of people visiting my gallery would pick my painting as the man's creation and Markos's as the one done by a woman. So much for pre-conceived notions.

Here, then, is how I paint eyeglasses, Herb's and those of everyone else who wears them:

STEP ONE With a gray that's not too contrasting to the flesh tone, mark the top, the bottom and the corners where the ear piece meets the glasses. The eyeglasses are started with mere indications of the lenses.

STEP TWO Then, look at where the frames of the eyeglasses are lighter than the flesh tone (the highlights), and paint these places with the appropriate light tone. The bridge is put in.

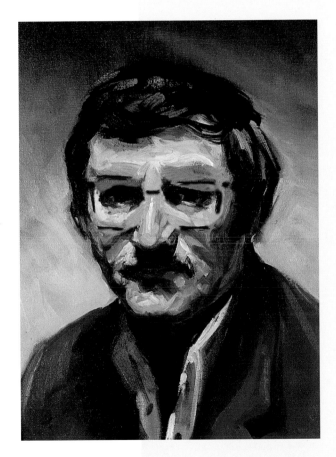

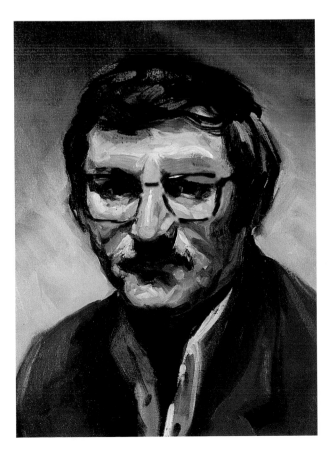

STEP THREE Paint the ear piece in the tone you see and fix the hair as it is affected by the ear piece. The ear pieces are then located. This is when you find out if the ears are in the right place.

STEP FOUR

Then, with a small brush, carefully connect the marks you made originally, thus outlining the shape of the glasses. All the marks are connected to complete the addition of the eyeglasses.

If you're adding eyeglasses to a portrait that you have painted loosely, merely suggest the outline of the glasses, adding any cast shadows on the face from the frame. Use a warm gray for this. If the portrait has a more finished look, the glasses then have to be rendered in that same finished fashion.

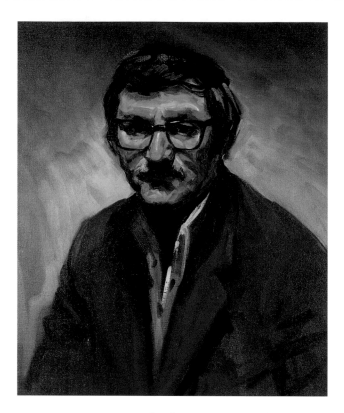

Finished painting, **Herb in Red Coat,** *24" x 30", oil on canvas.*

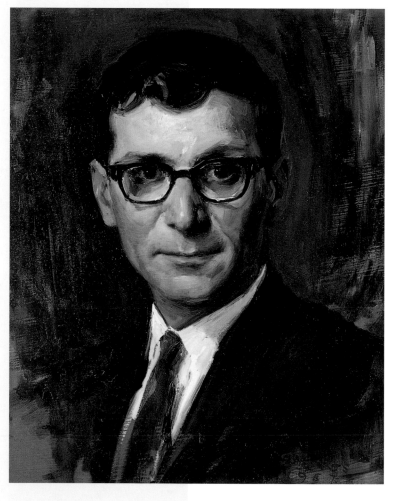

Herb Rogoff, painted by Lajos Markos, *14" x 18", oil on Masonite pressed board.* A sensitive interpretation of my favorite model.

Painting Hair

❧❦❧

Hair is many things to many people. To a woman model, her hair may be her crowning glory. To some male models, hair may be a fond memory. To the portrait painter, however, hair is just part of a likeness and just another texture that has to be painted convincingly and artistically. The basic procedure for hair, if there is enough of it, is to paint it in three distinct applications.

The first application will roughly establish its style and how it covers and extends from the head.

The second application adds contrasts of tone to this basic shape. They are the highlights and shadows. These tones are best applied in directions that are absolutely opposite to the way the hair is combed. Once these colors and contrasts are applied, they can be "combed" with a dry or semi-dry brush in the direction that the hair is falling or combed.

The third, and final, application can be described as actually "combing" the paint with strokes. The hair-like texture that appears, from this step, always has to be defined with some accents of lights and darks that are applied, once again, in the direction that the hair is combed or growing.

It's very obvious that the outline of the hair as it meets the background is the silhouette of the model. This outline has to be carefully treated. A complete, sharp delineation will make the head look pasted onto the background. Avoid this look by utilizing a combination of sharp and fuzzy edges, most easily accomplished by combing the hair out over the background.

Now for the color of hair. All hair colors are versions of yellow. This is obviously evident in brassy blondes. In old women, or carrot-topped kids, the hue identification is a bit more obscure. With this in mind, a general color classification is better than trying to learn the color mixture for every hair color. The color yellow can be the following versions:

1. Light and bright for brassy blondes, made of Cadmium Yellow Light.

2. Light and less bright for ash blondes, made of Yellow Ochre or Raw Sienna.

3. Darker yellows for brown hair, made of Burnt Umber or Burnt Sienna.

4. Even darker yellows for brunettes, made of Burnt Umber.

5. Orange yellows for chestnut colored hair, made of Burnt Sienna and Cadmium Orange.

6. Very orange yellow for redheads or carrot tops, made of Cadmium Orange and Cadmium Yellow Medium.

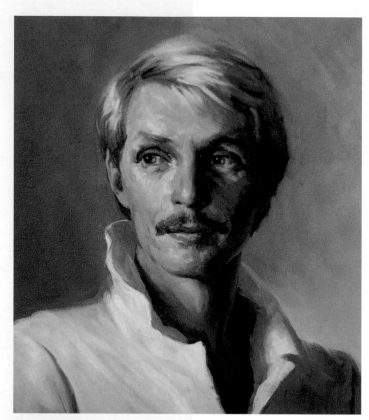

Dee Landergren. His blond hair appealed to me.

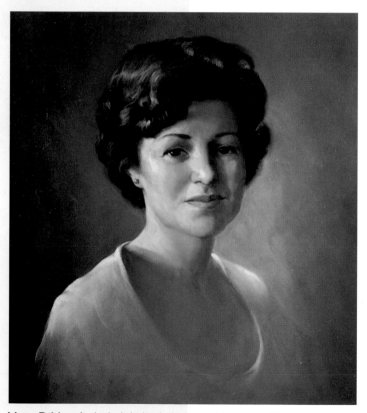

Mary DiNapoli. A dark-haired, dark-eyed beauty of Sicilian descent.

When it comes to painting black or gray hair, we have to realize that these colors are viewed with a light on them, usually a warm one, which makes these seemingly colorless hair colors look warm. By adding Burnt Umber (a dark yellow) into a dark gray (black and white), you'll have a suitable color for the mass tone of black hair. For shadows in black hair, mix Burnt Umber, Thalo Blue and a touch of Alizarin Crimson. For highlights, a light gray with a breath of Thalo Blue, Manganese Violet or Alizarin Crimson. Very dark accents can be made with Alizarin Crimson and Ivory Black.

For gray hair, mix black and white for the tone of gray that the hair is, and add either Burnt Umber or Raw Sienna, depending on how yellow the gray hair looks. Even the so-called blue-gray hair has to be massed in with a suitable warmed gray. Shadows are cool-colored darker tones, and highlights are cool-colored lighter tones. The shadows are made by putting any cool color — mostly violets or blues — into dark tones of gray that are made of black and white; the highlights are cool into very light grays.

Since all hair colors are basically yellow, shadows on all hair should be in the violet family, more blue if the hair has an orange hue. The highlight should also be blue. Right next to the highlight, a bright, light version of the basic hair color can visually be seen, depending on the texture of the hair. This color isn't as visible in artificially colored hair; include it anyway to make the hair look more natural.

Among the many full-color photographs of portraits that I have done over the years, I found perfect examples of four different

hair colors. The mixtures that I used to paint the hair of these people will bear out what I have just written.

The first model is Dee Landergren *(on page 96)*, a computer whiz who on many occasions has bailed us and our PC out of a lot of problems. The color of his blond hair was made by using Yellow Ochre with Manganese Violet in the shadows.

Mary DiNapoli *(on page 96)*, the second model, studied with me and went on to be a good friend. To paint her black hair, I added Burnt Umber into a dark gray of black and white. For the shadows, I used Burnt Umber, Thalo Blue and a touch of Alizarin Crimson.

A real carrot top at the time I painted her, Denise Ryan (nee Driscoll), is the daughter of "Tuesday Lady" Eleanor Driscoll, and at this writing is a mother of two herself. For Denise's red hair, I used Burnt Sienna and Cadmium Orange with Thalo Blue for the shadows.

The fourth model shown here is a friend of thirty years, Robert Benham, a respected marine painter in Gloucester. I've never known Bob without gray hair because his hair turned at an early age. I treated his hair by adding a touch of Raw Sienna into a gray of black and white and then used Alizarin Crimson for the shadows.

Color mixtures are only one-half the instruction that you will need for painting hair successfully. The procedure is the other half. To show you how, I've chosen a self portrait that I painted in 1961. See how the basic procedure and basic analysis of color mixing is used in all the portraits that are pictured in this book.

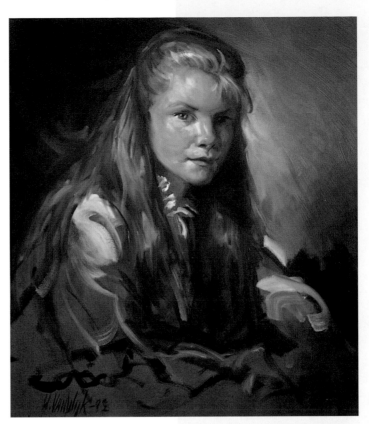

Denise Ryan. A true carrot top.

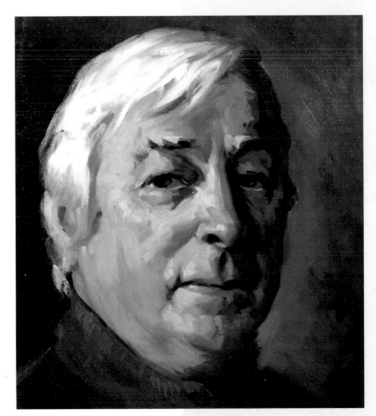

Robert Benham. His gray hair is his crowning glory.

97

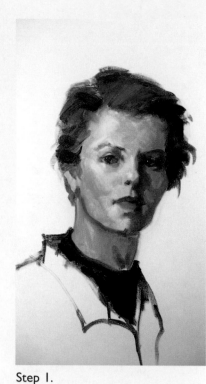

Step 1.

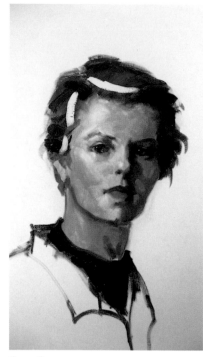

Step 2.

Step 3.

Step 1. The hair without lights added.

Step 2. The lights have been slashed in opposite to the way the hair is combed.

Step 3. Darks have been applied next to the lights.

Step 4. The values have been "combed."

Step 5. The hair has been refined and finished. Two important factors about your model's hair are: 1.) Its silhouette as defined by its contrasting background. 2.) The shapes of the highlights.

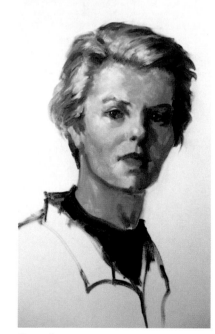

Step 4.

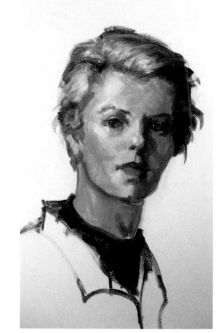

Step 5.

The finished portrait from which this step-by-step progression was prepared can be viewed on page 124.

Painting More than Head and Shoulders

A portrait that has more than head and shoulders in it can be painted on a small canvas; many of the painters of the past did it, magically managing to get a lot of the body painted on 20" x 24" surfaces, and even smaller sizes. "Catnap" (Figure 2) is a painting of my uncle that includes more than just head and shoulders, and I painted it on a 20" x 24" canvas. You can see it on page 101.

What we are concerned with in this chapter, though, is the business of creating a full — or near full — figure on a large canvas. Most portrait commissions that require more than head and shoulders will be on canvases that are usually 24" x 30" and larger. We have to keep in mind that the mega-huge portraits that are displayed in museums are the dinosaurs of the painting world. They were designed to hang in the palatial homes and castles of the titled gentry in Europe; most homes of today, even those owned by moneyed people, can't comfortably accommodate paintings that are larger than 30" x 40".

So much for sizes. What we really want to get into here are the mechanics of painting portraits that embody more than just head and shoulders. Your first concern: you have to pay a lot of time and attention to the large expanse of background and the larger amount of body that will be shown, not to mention the likely presence of hands. As a result, the head becomes a small fraction of the canvas but, at the same time, it still must function as the focal point. Here, you have to spend time and energy to painting the remaining areas of the canvas and, in the end, in relation to the face, these areas can't afford to be present with any more prominence than being merely important supporting cast members. This, then, becomes the major problem when painting a portrait that's larger than 20" x 24". I'd like to share with you some of the ways that I found to deal with the problem:

1. **Make sure that the model's position looks correct from side to side and from top to bottom.** Too much space anywhere on the canvas will make it needlessly important.

2. **Don't paint the clothing and hands with more detail than you did the face.** If anything, it's a good idea to underplay these items; merely suggesting their presence.

3. **Be very careful of how shapes look as they near the edges of the canvas.** You run the risk of drawing the viewer's eye from the face and toward the unimportant, meaningless edges that end at the frame.

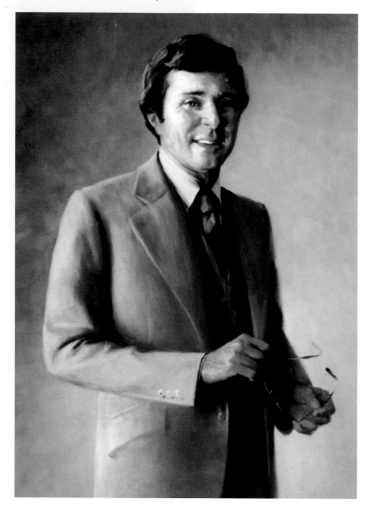

Figure 1. Michael Feldman. I would have removed the smile had he had the chance to pose.

4. Know how to paint clothing textures and how to paint folds. These are best learned by painting still lifes. Since these elements don't require a model's presence, you can practice painting technique to your heart's content without imposing on your model's time and patience. I can't stress strongly enough how valuable still life painting is. I have to tell you right now how annoyed I get with "portrait" students who only want to study the head and face. They come to class pooh-poohing any of my suggestions to paint still life. It goes without saying that in my classes, they don't get away with it; they will learn the basics of still life or out they go, heading back to wherever they came from. Practice plays an important role in being expert at anything. I truly believe that the way you look at, consider and paint an apple is the same as the way you will look at, regard and paint a person. You bring your expertise, or lack of it, to both subjects. I suggest that at this time you re-read my introduction to this book. In it, you will find that the lesson I learned from Rasko was a key to my progress, and ultimate success, as a portrait painter.

5. Hands constitute the biggest problem of a larger composition. Being a successful painter is knowing what you can do well and what you can't do well, or can't do at all. Hands that are busy, such as the obvious activity of holding a book or a letter, are easier to paint than hands that are idle.

6. I hope you realize that it may take some time — if ever — for you to get a commission for a painting that includes more than head and shoulders. Portraits of this type are hard to come by, but this should not stop you from painting one, or even a few of them, on your own. It's good business, too, because you will not even be considered for a commission of such magnitude if you do not have samples to show the client-to-be. Paint a few of these extra-large canvases by having friends and family pose for you. It's quite an experience and, what's more, it will prepare you for the time that someone may want you for an assignment such as this one.

Since hands are so vital when painting a large portrait, I would like to give you some pointers about painting them:

1. Only paint the hands in detail if they help describe the model's likeness.

2. Try to show, at least, one entire hand and part of the other.

3. Paint hands in darker general tones than those in the face.

4. Be careful how hands reach the bottom edge of the canvas.

5. If a hand has to disappear under clothing or out of the bottom of the canvas, don't let this happen at any joint, such as the wrist or the knuckles.

6. By all means, visit your local museum and study the way hands were painted in the large portraits on display.

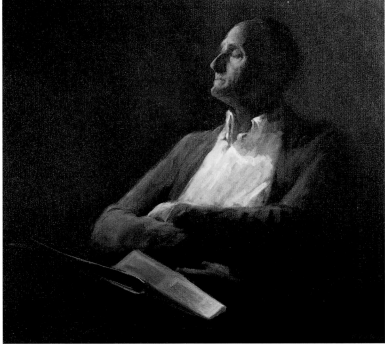

Figure 2. My uncle William Stap. I fitted a lot of figure into a small area.

We are lucky today to have such magnificent photographic equipment available to us and at relatively low cost. The technology is truly remarkable; you would be foolish, and it would be impractical, for you not to take full advantage of what photographs could do for the success of your portraits.

When I talk about working with and from photographs I don't mean that I want you to slavishly copy the entire photographic image. Not at all! You will find, when doing a large portrait, that there are many areas of the picture that could be done without the model being there, such as: when composing the piece, when painting the background, when painting clothing or when painting hands. Ideally, you want your model posing for you as much as possible, but you have to keep in mind that a life-sized portrait is usually commissioned by an institution — in and out of the private sector — and, logically, the subject is a busy individual. Your sittings, therefore, have to fit the crowded schedule of the person you are painting. I have painted a great number of these people, and I have found that all of my models approached their portraits conscientiously. They all considered their portraits consequential enough to set aside time to pose, but last-minute changes in plans, completely out of their control, could change all that, and often did. Even though the sitting would be canceled, I would still be determined to paint and, using the many photographs at my disposal, I'd work on a large portion of the portrait without the presence of the model.

My portrait of Michael Feldman (Figure 1) was done entirely from photographs. Michael is the founder and president of a successful construction company in Rockport, Mass. The only time

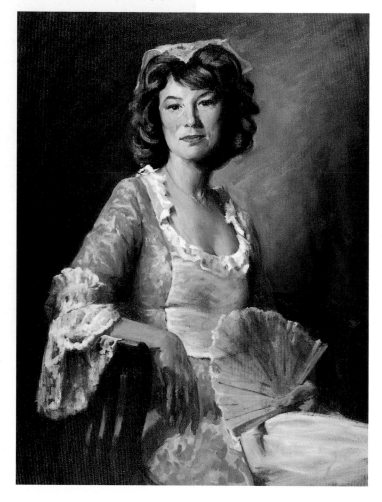

Figure 3. Solange Baumann. 30" × 40". I painted this portrait entirely from life. What a joy!

he was able to spare for me, as it turned out, was the hour or so that he posed for the photographs I felt I needed to have to supplement his poses. From that point on, I could never pin him down again to pose for me. Our schedules just didn't work out that way. After a few futile attempts to get together, I decided to paint him entirely from my photos. I never like to work this way, especially if my model is alive and kicking; it's far from a perfect situation for a painter. If I was to finish the job, however, it was necessary for me to make the concession. Had I had Mike pose for me, I would have used him just for his head, and I certainly would have changed his expression. Smiling, as he's shown doing, is such a photographic attitude. Avoid it at all times when painting any kind of a portrait. I photographed him for his body and hands, letting him do anything he wanted with his expression. I knew that I was going to change his expression completely when he came to pose. It never came to that, as I've just related to you, and I was stuck with what was on the photo. I learned a valuable lesson from that experience: from that time on, I always photographed my models with the same expressions that I planned to use for the portraits.

Whether Mike posed for me or not, I would have used the photographs for his hands. I had that in mind as I posed him holding his eyeglasses. I needed to inject some interest into a portrait that, because of its size, had to have hands in it. Many of my large portraits, incidentally, contain Herb's hands. Rather than take up the model's time, as I have just told you, and rather than rely completely upon the photographs, I would have Herb strike the pose, according to the way it appears on the photos. I then had the luxury of painting the hands from life, even though they didn't belong to the sitter in the portrait.

Getting back to Mike's picture, he loved the portrait and proudly displays it in the motel that he owns.

Time, as you can see, is all important in painting a large portrait. In the portrait that I mentioned earlier, the one of my uncle Bill Stap, I captured him taking a nap one day during his visit with his wife to Rockport. I saw him asleep with his newspaper in his lap

and painted this picture. Normally, for a painting that shows more than head and shoulders, I'd have used a canvas larger than 20" x 24". I couldn't do that in this case because it was important for me to finish the painting in one sitting since they were leaving the next morning.

While I have painted a number of large portrait commissions, I have also painted a few for my own use. One summer, at a workshop class, I included the painting of a large portrait in the schedule to demonstrate the mechanics of doing one. I let the students know beforehand that the demonstration was to show them how to start and then how to proceed from there. Finishing it at that session, or at others during the workshop week would not be practical.

My model was a lovely woman from Gloucester, Solange Baumann (Figure 3), who was a transplant from France. I asked her to wear for the demonstration the dress she had created expressly for our Bi-Centennial in 1976. My lesson that day was how to start a large portrait and how to advance it. Some weeks later, once my classes and demonstrations had ended for the season, Solange returned to my studio where I finished the 30" x 40" painting. Solange's portrait was one which I painted entirely from life. I took no photographs of Solange, choosing to do every phase of the painting on the spot. I must point out here that since Solange was seated and was comfortable, telling me so each time I asked, I was not imposing upon her comfort nor her time to paint her completely from life. It was a grand experience because, even though photographs serve the painter very well, they are merely weak substitutes for a real-life encounter.

The problem for the painter is that he has to re-create on a two-dimensional surface the three-dimensional figure who is on the model stand. Working from life affords the painter a fighting chance to pull off this caper. However, when a painter uses a photograph, he is trying to transport a two-dimensional image onto a two-dimensional surface, attempting to produce in the process the appearance of three dimensions. That's very tough to do. The sculptor is more fortunate in this respect because he is using a three-dimensional medium — clay, marble, wood, etc. — to portray his model.

What's the lesson to be learned? Try, as much as you possibly can, to paint from life. Recognize the value of photographs but use them sparingly. There are times, though, when you can't, as with Michael and in my painting of Paolo.

Figure 4. Paolo Pansa Cedronio. 24" x 40". I was reminded of Sargent's painting of President Theodore Roosevelt, but made adjustments.

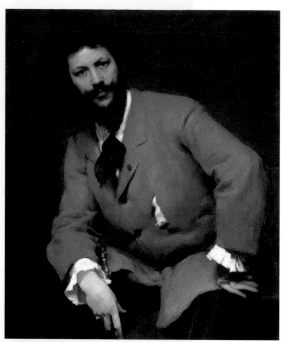

Figure 5. John Singer Sargent, Portrait of Carolus-Duran, 1879, 46" x 37¹³/₁₆", oil on canvas.

Figure 6. Herb Rogoff, 30 x 40". I "borrowed" Sargent's composition and learned much from it.

Painting Paolo Pansa Cedronio (Figure 4) was an interesting challenge. I had met Paolo in 1948 on board a ship from Italy bound for New York. I was eighteen at the time and was returning from a six-month trip with my father to Europe. I chose to take this vacation in lieu of a college education. I was captivated by Paolo, a suave, continental diplomat who, at that time, was the secretary to the Italian Ambassador to the United States. Eventually, Paolo became an ambassador in his own right, with assignments to England, Belgium, Chile, Canada and, finally, the U. S.

Many years later, when I found out that he was in Washington, I called Paolo to renew acquaintances; he invited me and Herb to visit. I photographed him in a pose that was loosely based on the portrait that John Singer Sargent had done of President Theodore Roosevelt. In that portrait, Sargent captured the President gripping the newel post of the stair railing in the White House. I asked Paolo to strike this pose for my photographs and he came up with the attitude that I chose to paint: leaning his arm over the railing. Gripping the post is certainly not Paolo's style. I painted the entire portrait from photographs since it was impractical for me to travel to Washington for sittings and difficult for him to come up to Rockport.

In the case of Paolo's portrait, I used a composition that was lightly based on one that had stuck in my mind. There's really nothing wrong with doing this. In my large portrait (30" x 40") of Herb Rogoff (Figure 6), I deliberately posed him in the same position that Sargent had used to paint his teacher, Carolus-Duran, in 1879 (Figure 5). Both portraits are shown here for you to see how you can "borrow" an already established composition. It's important to make sure that your painting carries some indication that the composition was not yours, that it was painted "after so-and-so." You must do this not only for possible legal reasons but for the decency that such credit calls for. Sargent's painting, incidentally, hangs in the Sterling and Francine Clark Art Institute in Williamstown, MA, a charming little museum. We have them to thank for the transparency that's reproduced here.

Chapter 26

Dealing with the
Difficulty of Portraiture

The factor that makes portrait painting different from painting other subjects is having to deal with a real life, blood-and-flesh model. It's obvious, especially to experienced still life painters, that a human model will never pose as still as, say, an apple does. But this deficiency is trivial compared to having to deal with a subject that has a personality and, what's more, an opinion. The model's very presence in your studio and the pressure that he will generate for you combine to make portraiture a unique painting adventure, more demanding and more difficult than painting still life and landscape subject matter. And don't forget the importance of motivation, which, in most cases in portraiture, is a commission that hires you, your time and your ability.

Alas, these are the problems that all aspiring portrait painters (and even accomplished ones, for that matter) must solve in their own way. All that I can do for you here is to enumerate some sound working habits that will not only help you to be a better painter but may also make it a bit easier for you to cope with a model.

To illustrate this chapter, I have selected some photographs taken by student Jane Bickford at a Friday demonstration one summer some years ago. The model was Dom DiStefano, an excellent watercolorist, art teacher and dear friend.

1. Stepping Back

When I am far enough back from my easel to see both my model and my painting I am in a better position to compare and judge differences in tone and shape and make necessary corrections (Figure 1). Even if each stage of development is a simple one, it will need correction, for no painter can paint with a brush full of guaranteed success. I have to set down with paint my analysis of what I see so I can see what it looks like. This makes correcting fifty percent of the painting experience. Each stage of a picture's development has to be painted, judged and corrected. So I look-paint-correct, look-paint-correct as I work on each stage. I paint because I want to; I correct because I have to. On a more optimistic note, by the way, stepping back can also show you how well you are progressing.

2. Squinting

Recording a face with paint, as you've no doubt already discovered, is no easy matter. Squinting helps because it diminishes your vision thus diminishing the job that the brush has to do at each stage. When you look at your subject with squinted eyes, you will see a simplified version of the many tones on the face. You will see the pattern of light and dark in stronger contrast than when you look with opened eyes. You will also see both of these tones with no details. Notice the simple beginning of the portrait of Dom. I was able to do this simply by squinting. Even though you can't see my face in the photo *(Figure 2),* you can believe me when I tell you — I am squinting.

Seeing your picture and model in reverse by using a mirror is always a shock to your actual visual reference. But it does help you to see your mistakes more easily. We are apt to become blind to the actual appearance of our pictures. Often, someone else can point out things about your painting because he hasn't seen it before, whereas you are accustomed to its appearance because of your hours of work on it. Let your mirror be that "someone."

3. Looking at Your Picture in a Mirror

Viewing your painting in a mirror is very revealing and helpful. The reverse image seems to look so different from the way that you are accustomed to seeing your picture that your own eye acts as a critic rather than a creator. Don't be afraid to respond to your own criticism. Dare to try to get the effects you see and want. This can only be done through bold experimentation and attitude that are difficult to assume when doing commissioned work. Be absolutely uninhibited by how the model wants to look and by how you think the picture should please him. In this way, you can paint without pressure and keep your mind on being a painter instead of a diplomat. As valuable as a mirror is as a tool, I do not use one at my demonstrations. I feel that it would interrupt the flow of the program were I to take time out at intervals to check in a mirror what I had done up to that point. Furthermore, at a demonstration the audience, not the painting, is my motivation. A good demonstrator sacrifices the painting for the audience. I do, however, tell all of the people in attendance about how important it is for a painter to check the painting in progress in a mirror.

4. Your Contract with Your Model

Unless you're painting a member of your family, or a friend to just keep you in practice, I have to assume that any portrait that you're going to paint will be a commissioned one. In that case, you will need some sort of an agreement with your model, who, in most cases, is also the client. The contract that I use seems, at first glance, to favor the client, but it is actually more beneficial to me and my portraits. Simply, it works this way: after price and size are agreed upon, my arrangement is — when the painting is finished — like it buy it; don't like it don't

buy it. Of course, a contract such as this one takes some confidence, but it relieves me of a pressure and an influence that can ruin my paintings. How can you commit someone to buy something that is only a possibility? Even you, as the painter, don't really know what the portrait is going to look like. My contract with my client offers me complete freedom of expression: freedom to do what I want to do; freedom to do my best. I need full rein as I stand in front of my easel to be able to paint well. Now, let's say, upon examining the finished portrait, the client doesn't like it and he takes me up on my contractual agreement. What have I lost? Time and some material, yes, but they are inconsequential compared to the worry of pleasing a model merely to justify the price that I have established. And what if your client doesn't like it? If a contract forces him to pay for the painting, he becomes the unhappy owner of a bad advertisement of your ability as a portrait painter. Another benefit of a contract such as this one is that it eliminates the time-consuming major changes that a client may feel the portrait needs. I will not make them just to suit the whims of the client. I don't mind making minor corrections that I hadn't noticed while painting the portrait. In a lot of cases, the client has been right about them, and I gladly make these changes.

5. Working from Good Reference Material

Referring to a model as "reference material" may seem cold-blooded but, as a painter, that is the most practical definition. How, then, can you make your model good reference material? For one thing, make him pose well: still and attentive. For another, don't allow your model to distract you from your work. A good way to make sure of this is not to let your model see the painting until it is finished. When you're painting from photographs, which you'll be forced to do if your subject is no longer alive, make sure that the photographs are of good quality and easy to work from. Remember, you can never alibi a bad portrait by saying that the model was a bad one or that you had an awful photograph to work from. A professional portrait painter has no excuses.

When you sign your name to your picture, your signature becomes a validation that you have done your very best. Your working habits, your experience, your knowledge, your discretion, your efficiency and your hard work are all of the ingredients that so often are casually referred to as talent.

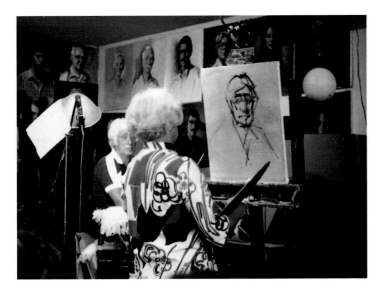

FIGURE ONE I started the demonstration of Dom DiStefano using black paint that was thinned with turpentine, which, when diluted this much, dries rapidly. Once I had the composition and drawing established, I stepped back to view what I had done.

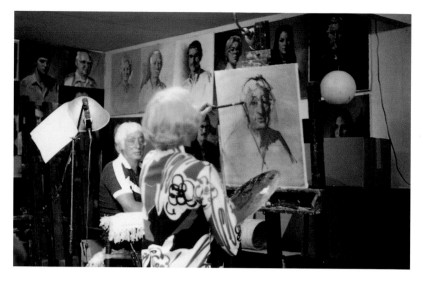

FIGURE TWO All throughout my demonstration I squinted to be able to focus on the simplified version of the many tones on Dom's face. Even though I squint throughout the painting process, it's in the beginning stages that my squinting is strongest.

FIGURE THREE This portrait of Dom was primarily done directly (*alla prima*). What you see here is the portrait at the stage of using gray to paint in the shapes of the shadows. I painted Dom's white hair and left it for further and later refinement.

FIGURE FOUR I put in the background, cutting it into the periphery of the head and then started to apply the body tone in the illuminated side of the face. The hair remained just as it was when I initially put it in.

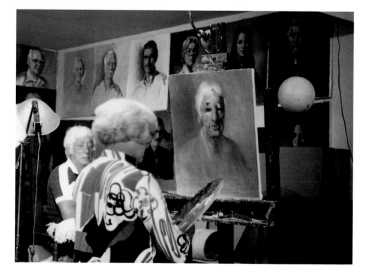

Pages 107–109 photos by Jane Bickford

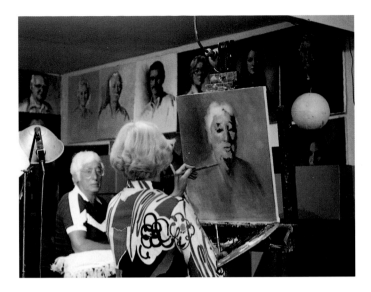

Into the shadow tone, I painted some flesh tone to fill the void that had been a colorless shadow. I worked on the shirt, the color of which I changed to blue from the brown one he was wearing. That's a painter's prerogative.

FIGURE
SIX I painted the hair and his head out over the background which gave him more of an appearance of living in an atmospheric environment. I worked on Dom's hair and added some darks behind his head to heighten the dimension. The calligraphic strokes that I added to the body did much to make the face look more finished.

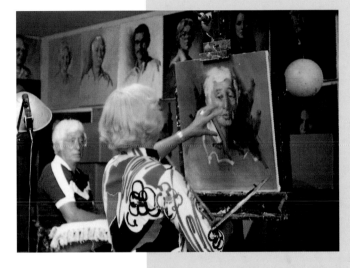

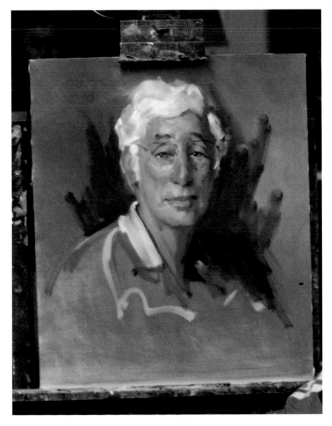

FIGURE
SEVEN *The finished portrait sketch.* **Dom DiStefano,** 20" x 24", oil on canvas. *A valuable two hours for the audience; a treasured experience for me and, I might add, also for Dom.*

Painting Your Family

❧❧❧

O f all the subjects for artists to paint — flowers, fruits, vegetables, oceans, rocks, trees, and so on — no subject is more difficult than portraiture. To explain, when painting inanimate subject matter, the painter needs no motivation other than the desire to paint a still life, landscape or seascape. A portrait, on the other hand, always requires the cooperation of another person, one who, in most cases, will pay you to paint him. Portrait painting, therefore, is dependent upon commission, which means, that you will feel compelled to accept all commissions regardless of how the model looks or acts.

I have been earning a living as a portrait painter for a half century and can happily say that I have had little or no unpleasant experiences with models. Maybe it's because of the prior arrangement I make with each one: you like it you buy it, you don't like it you don't buy it. I refuse to make any changes except for minor ones. Even with all that, which establishes a modicum of independence on my part, I can never forget, throughout the entire painting experience, that I am a hired hand, working to satisfy the paying customer before I satisfy myself. But this is the nature of the business, making this honest appraisal is the most difficult part of portrait painting.

I do, though, get the chance to paint anyone I darn well please, and this happens at painting demonstrations. Before the program, I spend time looking over the audience to find someone there who excites me, even challenges me. Picking my model in this way makes it easier for me, and my enjoyment then becomes the audience's enjoyment. I have had models who were so appealing, so "paintable" that I have at times told my audience, "Why don't you all go home so I can really concentrate on finishing this portrait?" This is always good for a laugh but I'm deadly serious, because in a painting demonstration, I sacrifice my painting for the audience. I guess I just can't win.

Another time when painting a portrait is sheer delight is when I have people over for dinner. I will, at times, after coffee and dessert, or sometimes during the cocktail hour, ask one of the guests if he or she would like to pose. It serves a few purposes: I get to paint an interesting person, one whose appearance motivates me; I can paint that person any old way I want to because it's one hundred percent mine; and the short demonstration can give a boost to a party that may be losing its luster of excitement. *(text continues on page 113)*

The Bride, *3" x 5", oil on gessoed board.* This is the only portrait I've ever done of my mother from a photograph. I had no choice because the photo had been taken of her right before she married my father. I wasn't painting then.

Time Out for Tea, *40" x40", oil on canvas.* When I spent six months in Europe in 1948 with my father, I was fascinated by the huge compositions in the museums I visited. I was especially interested in the Dutch genre paintings. I asked my mother to pose for this picture, which she was pleased to do. She turned out to be a good, cooperative model, and was extremely fond of how I portrayed her.

Alida DeBoer, *20" x24", acrylics on canvas board.* In 1963, Grumbacher, for whom I had been demonstrating, introduced its own version of acrylic paints and sent me a palette of colors to try out. I chose to do a portrait of my mother. As you can see, I painted the picture very realistically and slick, because I wanted to learn how far I could go with this medium. I realized then that the potential for acrylic artists' paints was far-reaching. I then demonstrated painting with acrylics for art groups all over the country, but I was always honest with them about my first love, oil paints.

The Matriarch, *24" x 30", oil on Masonite pressed board.*
In this portrait, my mother's pose came across to present
her as a stern disciplinarian, and I painted her that way.
This was far from the truth because she was a fun-loving,
easy-going person. Here's a case in which I should have
changed the pose to suit her true personality, but maybe
I was angry at her that day.

Herb in Denver, *20" x 24", oil on canvas.* Painted during
a tour of Colorado in 1964, this portrait of Herb was the
first one I did in front of an audience. I handled his cloth-
ing very roughly which made his face look more finished.

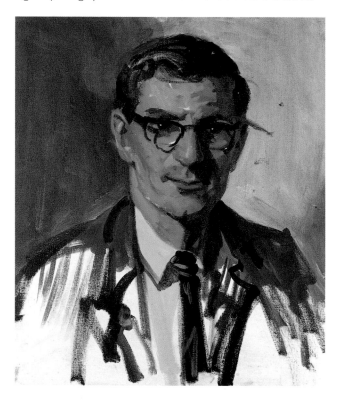

Watching TV, *20" x 24", oil on canvas board.*
The first portrait I ever painted of Herb. We
were in Old Orchard Beach, Maine, where I
was scheduled to do a painting demonstration.
It was during the off season and the weather
outside was bleak. As I prepared my materials
for that night's presentation, I looked over at
Herb watching the Warren Commission report
on television, and without even telling him,
I painted this portrait.

Now, I don't expect all of you to do portrait demonstrations or to paint your guests after downing a delicious pot roast. How, then, can someone interested in painting portraits get to do them often enough to gain the experience that a portrait painter needs? There are other avenues that are open to you outside of waiting around for commissions. One of them is obvious: attend an art class that would, of course, provide you with a model. Another way: you can get together with painting friends and all chip in to pay for a model.

The best solution, though, is right there in your home. Paint the people around you — members of your own family. I am sure your family, even your friends, will be willing to pose for you as long as you do not take up too much of their time. You can overcome that by taking photos of them and having them pose for short stretches to lock in some details for the final touches. If they are willing to devote more time to posing, make it easier for them by giving them frequent rests. Furthermore, rely on your photos for painting the background and clothing, areas of the painting that don't require their presence.

In paintings from the past, we have seen over and over again the use of some member of the artist's family. Two paintings that come easily to mind are the ones that Rembrandt painted of his mistress in "A Woman Bathing" and of his wife in "Saskia at the Bath." If these painting geniuses can do this, why can't any of us?

In the introduction to this book, I wrote of how reluctant my mother was to pose for my classes but how enthusiastic she was to sit for me. Mom was a cooperative model, giving me all of her attention. I have painted her several times. Four of these portraits appear in this chapter.

Another favorite model of mine — indeed, the most favorite — was my husband, Herb Rogoff. I have painted him more than 25 times, most of them in the venue of art associations around the country. I would choose him because Herb is such a good model, absolutely dedicated to the success of my presentation. Whenever I have chosen Herb as my model, someone in the audience would invariably shout out, "You've painted him so often you can probably do him with your eyes closed." I was always glad when that critical statement was voiced. It gave me the opportunity to tell the audience that every painting experience is different, even though the subject is the same. The factors that are involved are my state of mind during each painting session, the message the model sends to me at that particular moment, the lighting that I'm forced to use in my alien "studio," and, very important, the mood of the audience.

I've also painted Herb at times other than in front of audiences. He may be reading a newspaper and I'd say, "Just continue doing what you're doing," and I'd grab my paints, a canvas and I'd be off to the races. Or it can be the way the light falls on his face that inspires me to paint him at that very moment. You will find a number of portraits of Herb that I've reproduced here. I like to call the collection my "Herb Garden." Look them over carefully. I'm sure you will agree that they're far from carbon copies of someone who is extremely well-known to me.

I certainly hope that each and every one of you gets to paint a commission or two or three at some time in your career; this, after all, is the consummate compliment for a portrait painter. In the meantime, or between commissions, work on portraits of your family for that much-needed (even for professionals) practice and for the supreme satisfaction that it will give you.

Herb in Grosse Pointe, *20" x 24", oil on canvas.* This picture was painted in Michigan in 1965, one of our stops in a midwest tour. Herb was Public Relations Director at Grumbacher and, technically, was my boss. We joked about this often.

Herb on TV, *12" x 16", oil on canvas board.* Done for one of my television shows, this picture of Herb is one of a very few in which his eyes don't look at me. By the way, if you pose your model to look directly at you, the eyes in the finished portrait will follow anyone viewing it no matter where that viewer stands.

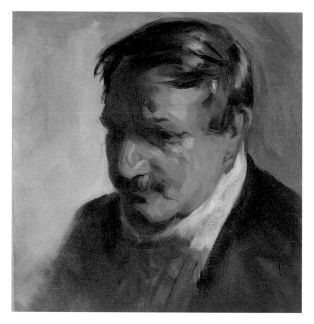

Detail of Herb in Acrylics, *12" x 16".* Originally a painting in acrylics, 24" x 36" in size, this portrait appeared in my book, *Acrylic Portrait Painting* (out-of-print). About twelve years after it appeared, I repainted the portrait in oil colors and cut its size down drastically.

Herb in Texas, *20" x 24", oil on canvas.* Whenever we would arrive in a town where my demonstration was scheduled, Herb would get the local newspaper to check the publicity coverage for the event. As he sat in front of the window thumbing through the newspaper, I was captivated by the back lighting and photographed him with my Polaroid camera. Years later, in my Rockport studio, I painted this picture. Can we consider this a portrait even though none of his features are in evidence? Why not?

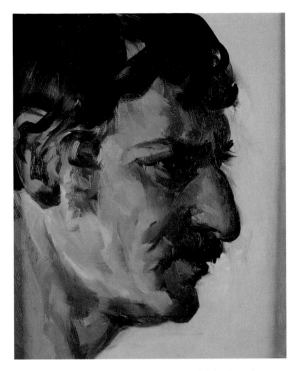

Herb with Beard, *20" x24", oil on canvas.* Herb had his beard for a very short period but long enough to pose for me at a demonstration back home in Massachusetts. I hated the beard (as did Herb) but loved the way I painted it: monochromatic except for the colorful flesh tones and red turtleneck.

Herb in Profile, *6" x 8", oil on wood.* My favorite painting of Herb because it's my very private look at him. No one who has seen the painting has remarked that Herb is without his eyeglasses.

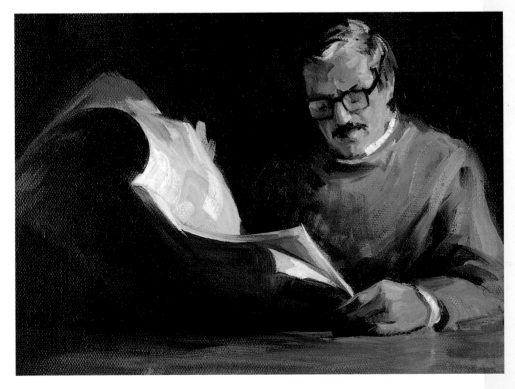

Herb on Sunday, *12" x 18", oil on canvas.* Every Sunday morning our home, like millions of others, was devoted to the *New York Times.* I photographed Herb reading the mammoth collection of newsprint, painting the portrait later in the quiet and privacy of my studio. Make use of your camera. It's a valuable tool.

Painting Yourself

✤✤✤

"You can't paint a good picture until you've seen a good picture." I don't know where I've heard that but, you must admit, it's pretty wise. I'm always after my students and people at my demonstrations to get out to museums. It's a valuable learning experience to see what the masters had done centuries ago.

Herb and I have visited a great number of art museums in this country and throughout Europe. Waiting for us on each visit, regardless of the city we happen to be in, are the same painters but, of course, with different pictures. You will always find paintings by Velazquez, Rembrandt, Van Dyke, Hals, Sir Joshua Reynolds, and John Singer Sargent, to name a brilliant few. Their output was staggering; the quality and impact of their products continues to be inspiring.

Did you ever stop to wonder that despite the growth of a technology that has so radically affected many other facets of our culture, representational painting has never changed? Each time I look at the paintings of the Old Masters, I never fail to marvel at the components they used to build their pictures; they are the very same components, incidentally, that I've just written about in this book and others under my authorship.

Their compositions were remarkable in how much they could get into a small canvas. They were also called upon to fill the giant canvases that were needed to decorate the immense palaces that the aristocracy called home.

I love to study the rhythm of application in the faces and in the variety of fabrics that people of the past — especially during the 18th century — wore. Velvets, satins, silks were some of the fineries of that era. What great textures to study! How these painters treated them are revelations!

The most fascinating portraits, at least for me, are the many self portraits that are

To set yourself up for a self portrait, first hold a hand mirror and look at yourself. Find the lighting that intrigues you and then, keeping that same view, set up a larger mirror on an easel. Then, in front and to the left or right of the mirror, set up your easel with your canvas on it and you are now ready. Look at yourself and decide what to do and then watch what you are doing. Don't try to look and paint at the same time. Painting is always looking, analyzing what you're looking at and then painting what your analysis is. You don't have you on the brush; you just have paint. Therefore, you must think in terms of paint: its color and the shapes these tones and colors make.

on display. Since Rembrandt is reported to have painted more than seventy, you're sure to see at least one in a major museum. Rubens has painted himself a few times, so has Van Dyke, Velazquez, and others. Joshua Reynolds, the great English artist, painted a self portrait that is indeed unique. It pictures the artist peering out at the viewer while shading his eyes with his left hand. It was interesting, too, to find self portraits of artists whose paintings were known to us but not their own likenesses. And then there were self portraits of other artists whom we didn't know at all.

One feature about all of these self portraits was truly amazing. No matter who the artist may have been, his self portrait stood out sharply from among his other paintings in that particular gallery of the museum. I could spot it from a distance and, upon closer study, was never surprised that it was a painting of the painter himself. As a portrait painter, I could see immediately the reason for this. When painting a self portrait, the artist is free of any of the pressure that comes with a commission since the painter has only himself to satisfy.

As a teacher, it has always surprised me that so few students, especially those interested in portraiture, will paint self portraits. Using yourself as a subject is an ideal way to study: You can dare to experiment with any kind of lighting; you can dare to take as long as you want without tiring your model; you can paint completely objectively; and if you make yourself look younger and better looking it will prove that you have a healthy, optimistic outlook about yourself. The development of a self portrait gives me a chance to review the important painting principles and how they function. Each one has been singled out and stressed in the preceding twenty-seven chapters. One by one they are rather easy to understand and apply. But it is their interrelationship that is the true makeup of painting and this is what makes painting such a complex challenge. Here are some thoughts about one component's influence on the others:

- Doesn't the arrangement of tones (lights and darks) determine the composition?

- Doesn't contrast of tone record shapes which is the drawing?

- Doesn't the tone of a color contribute to the correctness of the color?

- Doesn't the way two tones meet influence the appearance of the so-called line? Found: sharp; lost: fuzzy.

- Isn't the rhythm of application of paint a matter of applying a tone of a color?

STAGE **ONE** The placement and the establishment of the head size.

STAGE **TWO** The many lines I need to show the proportions and structure of the face.

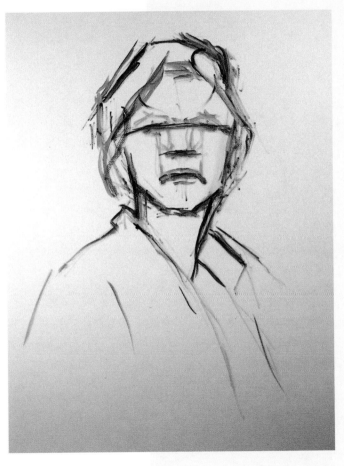

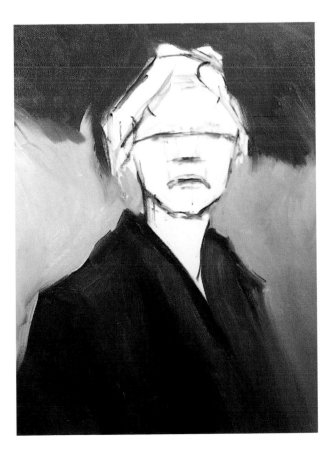

STAGE **THREE** The beginning of the tonal composition.

119

STAGE FOUR The completion of the tonal composition. This is the most important stage — it records an image of me. It was this very lighting that intrigued me enough to put me to work at my easel. This is the result of the first painting session and was done in tones of gray made of black and white greatly thinned with turpentine.

STAGE FIVE The basic tonal composition has been developed. 1) I painted darker tones into a dark flesh to show the beginning of my features. 2) The only light body tone of the form was the light on the outline of my hair which I painted in with darker tones of my hair to be a soft foundation for the subsequent stronger contrast. 3) I painted in a light-toned background and the dark tone of my blouse and boldly decided on the found-and-lost lines of the silhouette. 4) I also began working on the dim small amount of reflected lights on the right side of my face.

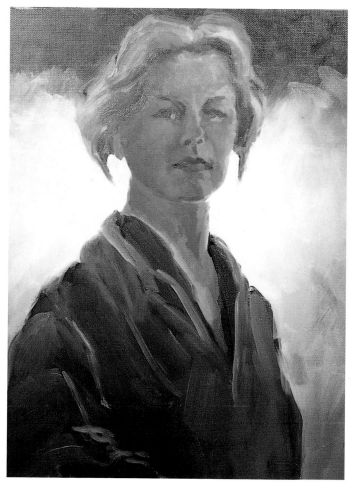

STAGE SIX I started painting the background and working on the tones within the basic tonal composition.

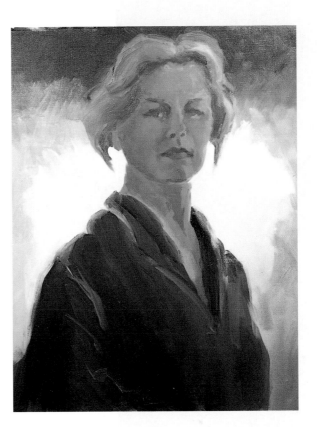

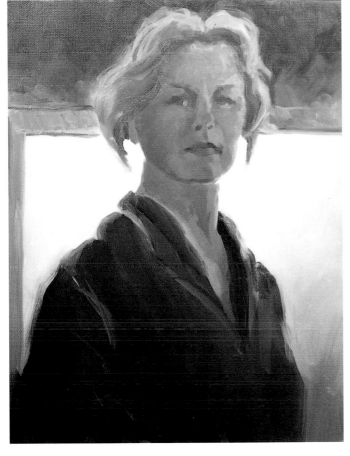

STAGE SEVEN I painted the background into the outline of my form.

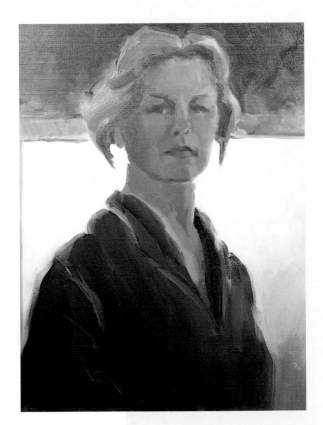

STAGE EIGHT I added more lights to my hair and refined the outline.

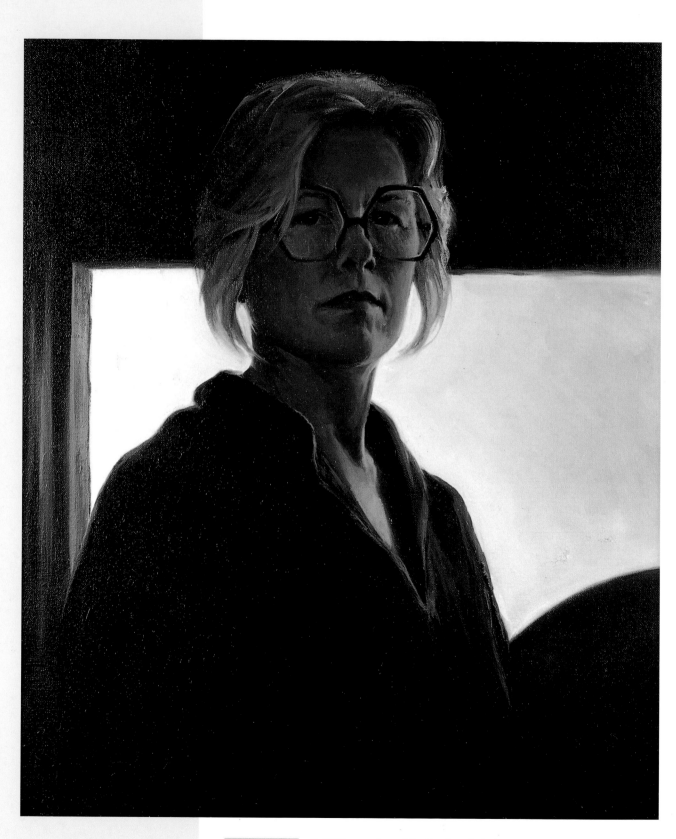

STAGE **Self Portrait with Back Lighting,** *22" x 28", oil on*
NINE *Masonite pressed board.* Compare this finished portrait with Stage 4. You will see how it is just a development of it. No tones have been used to alter that basic pattern of light and dark.

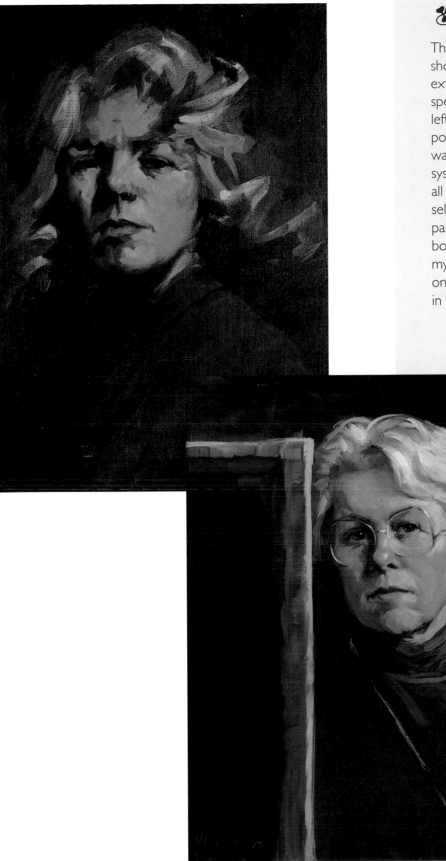

The two self portraits shown here are at opposite extremes of the attitude spectrum: the one at the left — 16" x 20" — is a portrait that every painter wants to get out of his system. It is not flattering at all but, I feel, one of the best self portraits I have ever painted. The one at the bottom— 20" x 24" — is my latest self portrait, and one that's entirely different in mood.

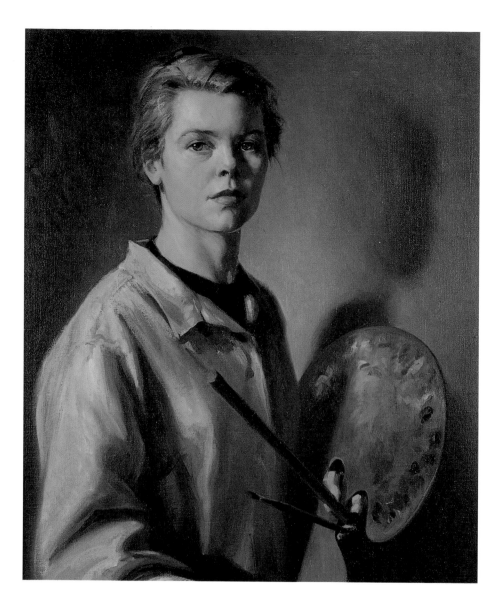

I've ended this portrait painting book with a portrait of myself that is very significant. I painted this picture, which I am sure many of you have seen before, in 1961, and had a chance to show it to Mr. Rasko shortly before he died. As a tribute to Rasko, I had borrowed the composition from a self portrait that he had painted. Even though Rasko was gravely ill at the time that I brought the portrait to his studio, the similarity in composition didn't escape his notice. He looked at it and smiled.

I knew he was pleased.

I am presenting this portrait to you at this point in my book with thoughts that it would add a more appropriate touch than succinctly saying, "The End." There is no end, for the study of painting is ever ongoing. Each thing we learn seems to be another beginning, as Mr. Rasko observed when, seven years after I had left his studio, he came to the first exhibition of my paintings. His comment: *"Helen, now we can begin."*

Index

Paintings by Helen Van Wyk

Instructional Illustrations by Laura Elkins Stover

Helen Van Wyk Videos & Brushes

Now that you have an instruction book by Helen Van Wyk, you may want to fortify this information with Helen's eloquent demonstrations on video tape. Once you have viewed the techniques shown in the videos, you will understand why Helen Van Wyk is considered by multitudes of artists to be America's most effective teacher of realistic painting.

Brush Techniques: Your Painting's Handwriting

Universally recognized as the most important tool in painting, the brush remains a mystery in the hand of a painting beginner as well as in more experienced hands. In this one-hour video, Helen demonstrates how versatile brushes can be when used properly, for each painting you do. *60 Minutes, $24.95*

Oil Painting Techniques & Procedures

A two-hour demonstration of a still life. It starts with a monochromatic underpainting and is followed by glazing applications to end with direct *alla prima* touches. Finally, the technique of glazing is fully explained and illustrated. In this still life, you will see Helen paint every kind of texture which will help you with all the subject matter you may encounter in your still lifes. *120 Minutes, $49.95*

Painting Children from Photographs

At last, you can paint the child in your life without fuss and stress. This one-hour video shows you how to go about it. Helen tells you what kind of photographs are best suited to use as models. And once you're set on one, she explains, in easy-to-understand instructions, how to transfer it to canvas through the grid method. *60 Minutes, $24.95*

A Portrait: Step-by-Step

In this one hour video, Helen covers every facet of portrait painting. You will learn about mixing the right flesh color, getting the shadow to look just right, and that difficult "turning edge," the area between light and shadow. If portraits are your interest, you won't want to miss this sterling, informative video. *60 Minutes, $39.95*

Elegant Abundance

During the 16th and 17th centuries, Dutch still life painters were producing masterpieces that were emblematic of the so-called Age of Elegance. In this 90-minute video, Helen recaptures that era with her superb still life that bursts with subjects and textures: lemons, silver, lobsters, glass, flowers, and more. If still life is your painting passion, you must own this stunning vehicle of instruction. *90 Minutes, $24.95*

Painting Flowers *Alla Prima*

Alla prima is an Italian phrase that means "all at once." In this one-hour presentation, Helen demonstrates this direct application of paint to interpret a bouquet of daisies. Throughout this video, you will learn how Helen gets her paint moist and juicy, a look that has entranced viewers of her TV show and live demonstrations. *60 Minutes, $39.95*

Kissing & Warm Colors

Encouraging us to think carefully about how we draw, Helen shows how "kissing" can make us confused about our subject. Helen teaches the "hot" subject of orange with a full demonstration of a still life that includes orange fruits and a vase.

The color is red, the subject is passion… Helen introduces us to still life involving leather books, wine glasses, covering lessons such as how to add passion to your paintings and how to paint reflections and glass. *75 Minutes, $29.95*

Strike a Pose

Helen studies and captures realistic flesh colors from a doll as if it were a real person, showing how you can capture the notoriously hard realism of skin. Helen tells us to ensure models are in a pose that relate to their personalities — more dominant people should be painted from below — the shy, from above denoting deference. *60 Minutes, $24.95*

Symphony of Light

Helen tackles the difficult shape and contours of a violin with a full demonstration and takes us through every step of the painting. You'll see how adding light and shadow will vastly improve your work and learn that is all achieved in a series of easy to follow stages. *60 Minutes, $24.95*

Conquering Earth & Water

With each stroke of Helen's brush you will learn to capture the feel, the light and the splendor of a close observation, whether it is a landscape or a seascape. Helen begins by painting a view from her studio and then moves onto a seascape where you'll learn to paint water crashing against rocks and make waves come alive. *60 Minutes, $24.95*

The Wonderful Color White

Helen shows you, through a complete demonstration, how to paint the color white and how useful it is. Covering color mixing and offering guidance about light & shade, this strangely interesting subject holds quite a few surprises as Helen paints a still life. The final lesson in this video covers snow, in particular its color, as Helen paints a winter scene of an old red barn. *75 Minutes, $29.95*

HELEN VAN WYK'S BRUSH SELECTIONS

The Overture Selection

This five-brush selection has been designed to serve you well throughout the development of your painting *right from its start*. They are made of a durable synthetic that won't curl or stretch. The soft-textured *Overture* brushes perform very much as sable brushes do but at a considerable fraction of their cost. *$36.95*

The Finale Selection

The five brushes in this selection were made specifically for the finishing touches of any painting. They are those parts of the painting that you usually are faced with from two-thirds done to the end: ornamental designs, highlights and, finally your precious, distinctive signature. What better name than *Finale? $31.95*

ORDER FORM

ORDER BY PHONE, FAX, E-MAIL, OR MAIL THIS COMPLETED ORDER FORM WITH YOUR PAYMENT TO:
DESIGN BOOKS INTERNATIONAL, P.O. BOX 1399, TALLEVAST, FL 34270

Phone: 941-355-7150 **Fax:** 941-351-7406 **E-mail:** designbooks@worldnet.att.net **Web site:** www.helenvanwykvideos.com

Please send me the videos/brushes I have checked below:

- ☐ Brush Techniques: Your Painting's Handwriting **$24.95**
- ☐ Oil Painting Techniques and Procedures **$49.95**
- ☐ Painting Children from Photographs **$24.95**
- ☐ A Portrait: Step-by-Step **$39.95**
- ☐ Elegant Abundance **$24.95**
- ☐ Painting Flowers "Alla Prima" **$39.95**
- ☐ Kissing & Warm Colors **$29.95**
- ☐ Strike a Pose **$24.95**
- ☐ Symphony of Light **$24.95**
- ☐ Conquering Earth & Water **$24.95**
- ☐ The Wonderful Color White **$29.95**
- ☐ Overture Brushes **$36.95** ☐ Finale Brushes **$31.95**

Name _____

Address _____

City _____ State _____

Zip _____ Phone _____

☐ Payment Enclosed $ _____ (or) Charge my ☐ Visa ☐ MasterCard

Add $4.50 Shipping & Handling.
Florida Residents Add 6% State Sales Tax.

Acct.# _____ Exp. Date _____

Signature _____